TRINE BAKKE

Patchwork
Quilts
Scandinavian Designs for
the Modern Quiltmaker

TRANSLATED BY
KIM GARDNER

Skyhorse Publishing

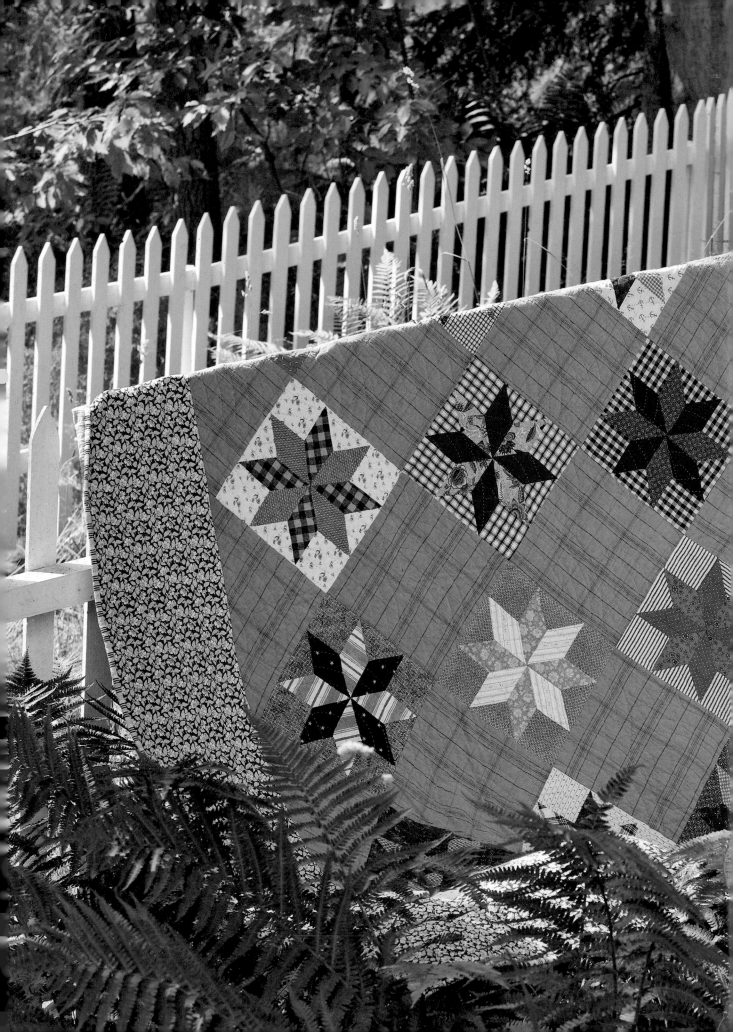

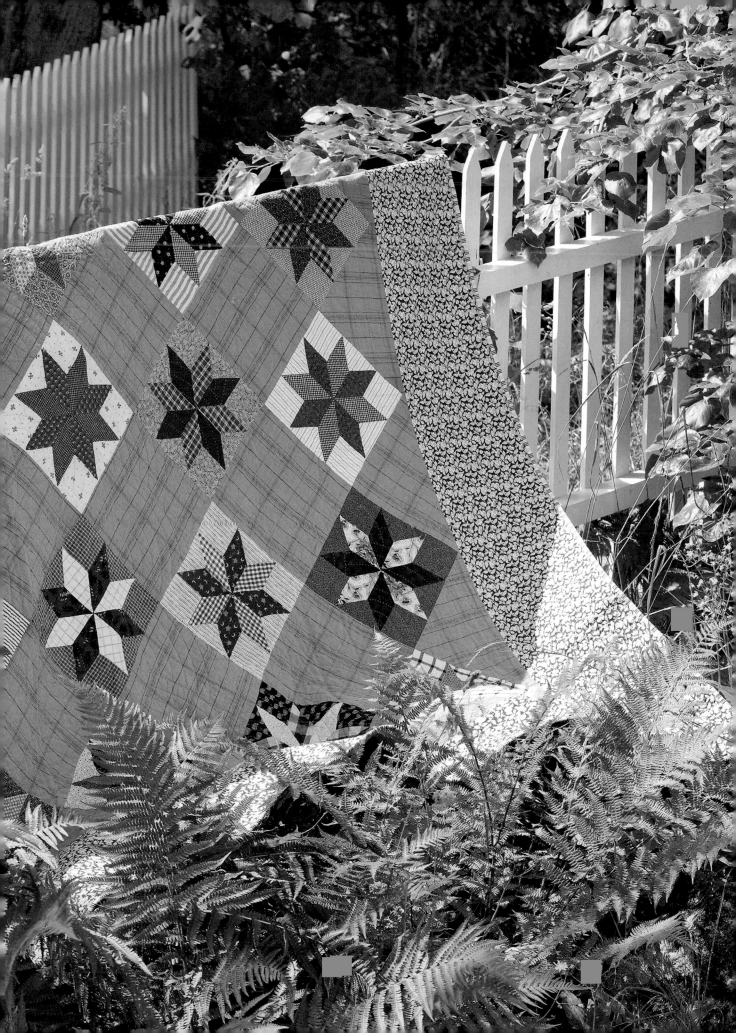

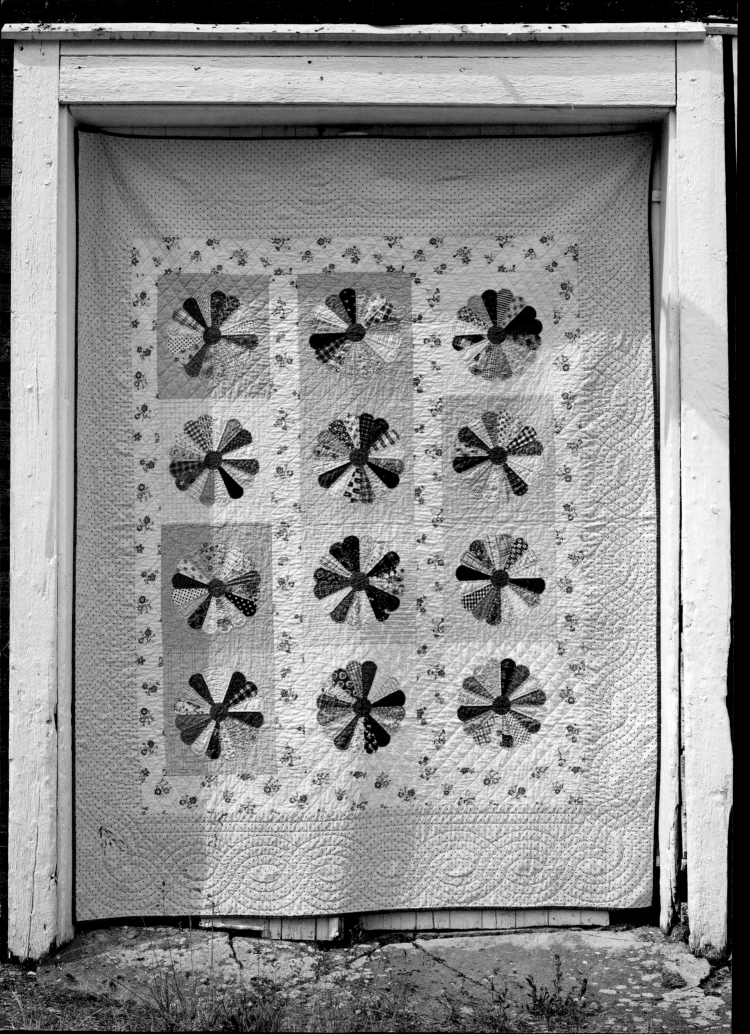

TRINE BAKKE

Patchwork Quilts

TRANSLATED BY
KIM GARDNER

Skyhorse Publishing

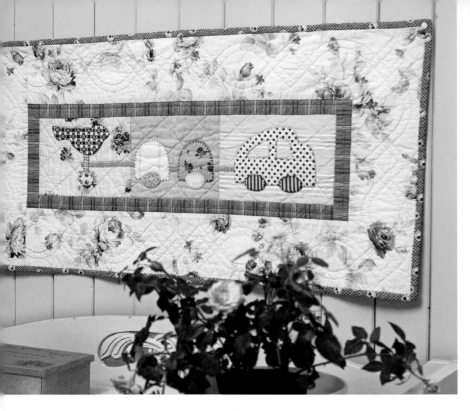

Skyhorse Publishing books may be purchased in bulk at special discounts for sales promotion, corporate gifts, fund-raising, or educational purposes. Special editions can also be created to specifications. For details, contact the Special Sales Department, Skyhorse Publishing, 307 West 36th Street, 11th Floor, New York, NY 10018 or info@skyhorsepublishing.com.

Skyhorse® and Skyhorse Publishing® are registered trademarks of Skyhorse Publishing, Inc. ®, a Delaware corporation.

www.skyhorsepublishing.com

10 9 8 7 6 5 4 3 2 1

Library of Congress Cataloging-in-Publication Data is available on file.

ISBN: 978-1-62087-089-1

Printed in China.

Enough light for your sewing? Stitches too small and colors difficult to see? Color looks different in daylight and lamplight. I usually let my fabric combinations stay open for consideration for several days, then I get to see how they look in all kinds of lighting. Janome has daylight lamps providing just that: daylight. They come in different colors and designs, and the prettiest could even stand in the living room. There is also a magnifying glass, with and without light. Smart stuff. Maybe color testing over several days isn't necessary? www.ottlite.no

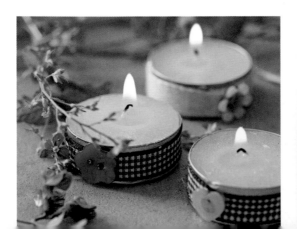

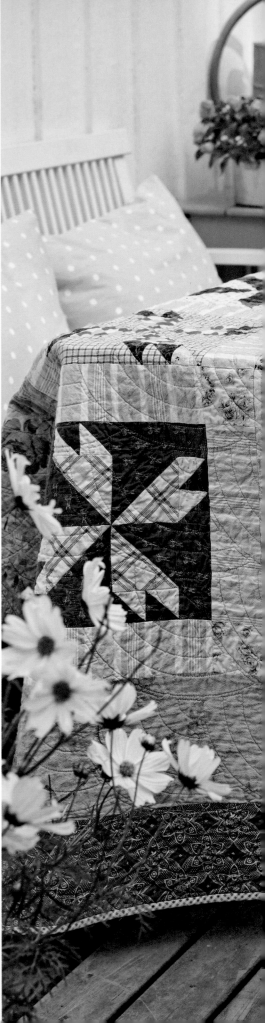

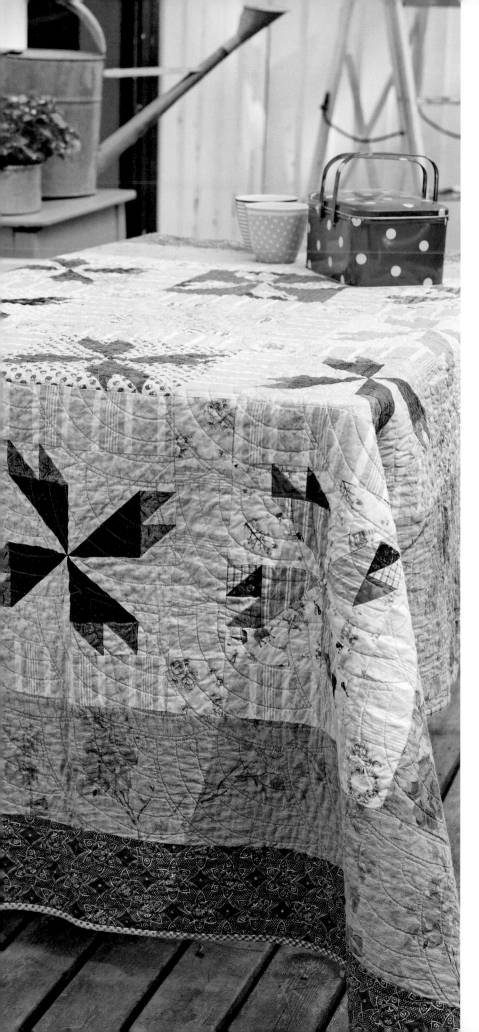

Contents

To Anne X 2 ...
Anne-Kjersti Johansen
and Anne Fjellvær

Dear Reader,

Quilts should be washed and used. Then they get good and soft. In this book, I hope to inspire you to do just that. I wash and iron all of my fabrics before I sew them. Additionally, when the last stitch on the border is sewn, I wash the entire blanket. With unwashed, thin, high-quality cotton batting, like Request or Soft Touch, my blankets end up "suitably worn, a little shrunk, and old"—precisely like a beloved great-grandmother.

I seldom hang quilts on the wall. I hang pictures there. Quilts should be used—for the sofa, on the bed, for the sun chair, over a chair back, on the veranda, on the table, in the car, and on the boat. My inventory of runners and blankets are folded nicely together and lie in wait in shelves and baskets, a joy to the eye. Do likewise; use your blankets and display them.

A couple words about washing quilts: Choose about 100 degrees F (40 degrees C) for a fine wash and gentle spin. Preferably, add a color-trapping cloth. End by drying the quilt flat on the floor, preferably on a clean sheet. Blankets with cotton batting should NEVER BE HUNG to dry, since they lose their shape.

Hope you use your quilts and that they get washed—then they get beautiful!

Trine
www.lappemakeriet.no

About Tommer, Inches, and Centimeters

For the book, tommer—or inches, in English—are used. The reason, plain and simple, is that I have always sewn in inches and not centimeters. That is to say, I began with centimeters, but it soon proved that all of the course instructors I went with, and all of the books I wanted to read, operated with inches. So, I had to **krype til korset** [crawl to the cross] and use inches. Otherwise, nothing that I had sewn would match. Now, it's gone so far that I eye a measure better in inches than in centimeters. As a Norwegian in Norway with the metric system, I should naturally have used centimeters. I am **"En synder pa sommersol"** [A sinner in the summer sun], in other words.

If you use centimeters while reading this book, you have to use your head at the same time. One inch is the same as 2.54 cm. That means that you can take a number in inches and multiply it by 2.54 in order to get a number in centimeters. If the inches have a fraction after them, you first have to divide out the fraction. For example, 6¾ is the same as 3 divided by 4 plus 6. Therefore, first divide the fraction in order to get a decimal number (0.75), and then add the whole number that stands in front of the fraction (6.75). Who in heaven's name thought you'd use fractions after school? In order to convert 6 ¾" to centimeters, you have to do it like this: 6.75 x 2.54 is the same as 17.145 cm. The number is not easy to find on a centimeter ruler.

Therefore it's never good to count on. The solution is to start with the portions that I have counted out for you, and after that measure yourself when you get farther out in the seam process. Or, you could obviously ask for an inch ruler for Christmas.

The seam allowance is calculated to ¼" for the entire book. That comes to 0.635 cm.

Marti Michell (www.frommarti.com) has thought of a user-friendly device for us measuring-tool-perplexed patchwork ladies: a ruler that shows lines for both centimeters and inches. You sight yourself in on the measuring tool you use and follow the line over to what looks foreign. Then, converting from centimeters to inches and from inches to centimeters becomes an easy affair. Recommended.

About Printing Process Control Measures

You will see that I have often marked a line across a pattern and written a number on the line. That is a control measure from me to you. When you want to use an instruction, you should always measure the line I've marked. If it's as long as I've noted, then the world is problem-free. If it's too long or short, then the data control has gone outside the line, and you have to enlarge or shorten the mark until the control measure matches.

My grandmother died when I was a little girl, so memories of my grandmother are tied to the photographs we had of her. In one picture, she's sitting in the living room on Helgensen's Street. Wallpaper can be seen behind her. Once I saw the fabric for the borders in this blanket, I was reminded of the wallpaper pattern from my grandmother's picture and wanted to create a similar form in this piece. This is how I honor the memory of Grandma Ruth Tolfsby in this blanket.

Grandmother's Living Room Wall

Materials

Filler fabric:
- bright and lively patterned sashing about 88" (220 cm).

The flowers:
- around 40 to 100 different materials for the flowers, each piece about 4" (10 cm).

Frames:
- green-checkered frame about 24" (60 cm).
- flowered frame about 86" (215 cm).

Border:
- red border about 22" (55 cm).

Backing and batting:
- batting and back panel about 79" x 94 ½" (2 m x 2.4 m).

For machine seam only:
Place pin 60° in.
Secure well with start and stop.

Blanket measures 67 ¼" x 81 ¼" (168 cm x 203 cm) pre-washed and shrunk
Size of pre-sewn hexagon is 1 ¼" (about 3 cm) Measured along one of the six sides.

The Anatomy
The blanket consists of 31 flowers that have, for example:
1 yellow hexagon in the middle, 6 surrounding green hexagons, and 2 red ones on top and bottom (hat and neck).

The colors are varied on each block.

Additionally, there are 8 half flowers on the long sides and 10 hats/necks on the top and bottom. See picture on page 8.

Around 280 hexagons get a place in the sashing.

Special equipment
The hexagons can be sewn both by hand and by machine. Alternatively, they can also be cut out by knife with a plastic template if you can obtain one. I have used a plexiplastic template from Sharlene Jorgenson (Grandmother`s Flower Garden QS21) and a turning plate to a cutting board. My hexagons are sewn by machine. Start and stop one seam allowance's distance from the edge, and secure the seam well. See the sketch. Some sewing machines can be programmed so that you get the same length on the right seam each time and with attaching in starting and stopping. Eventually, you can do this also for a thread cut after the last stitch. If you have saved this as your own preset setting, the work will go a little easier. Each time you press on the pedal, run the machine exactly the same as on all of the previous seams you have sewn. Each seam has to be ironed open during the process in order to get a good result. It takes a long time to maneuver all of the pieces in place where they shall be sewn, and the blanket gets big and heavy in the machine accordingly. Afterward, I saw that it took just as long to sew by machine as it would have taken to sew it by hand over cardboard.

For hand sewing I would have picked Paper Pieces 1 ¼" (3 cm) Hexagon. The process is the same as in "Eight-Petal Rose in Original Transfer."

6

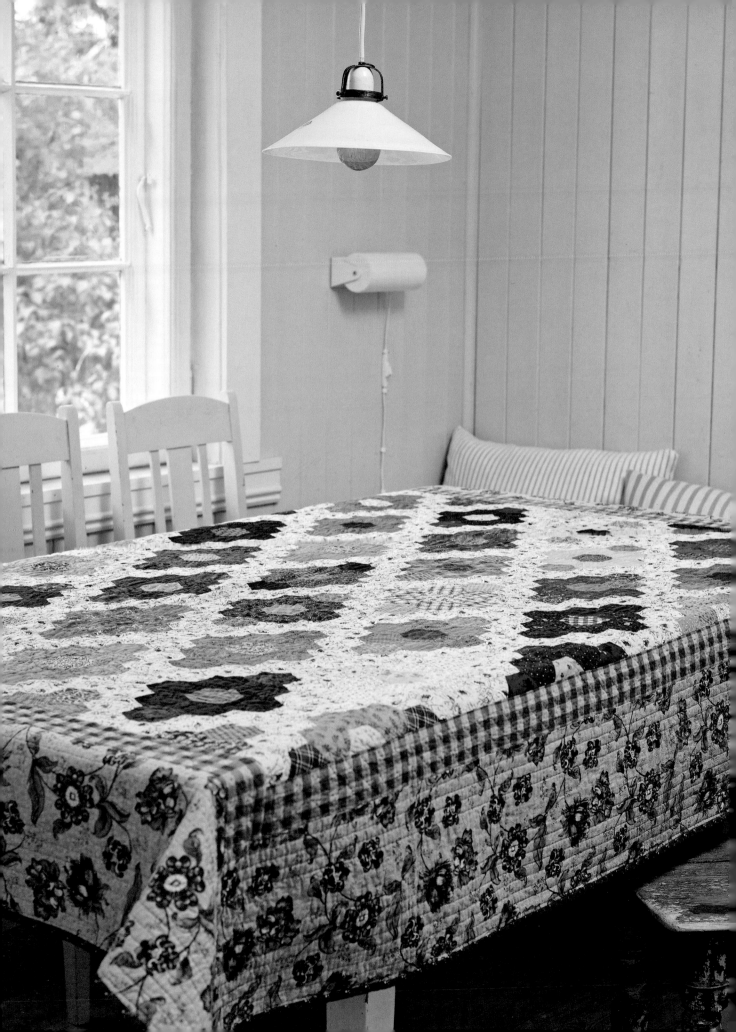

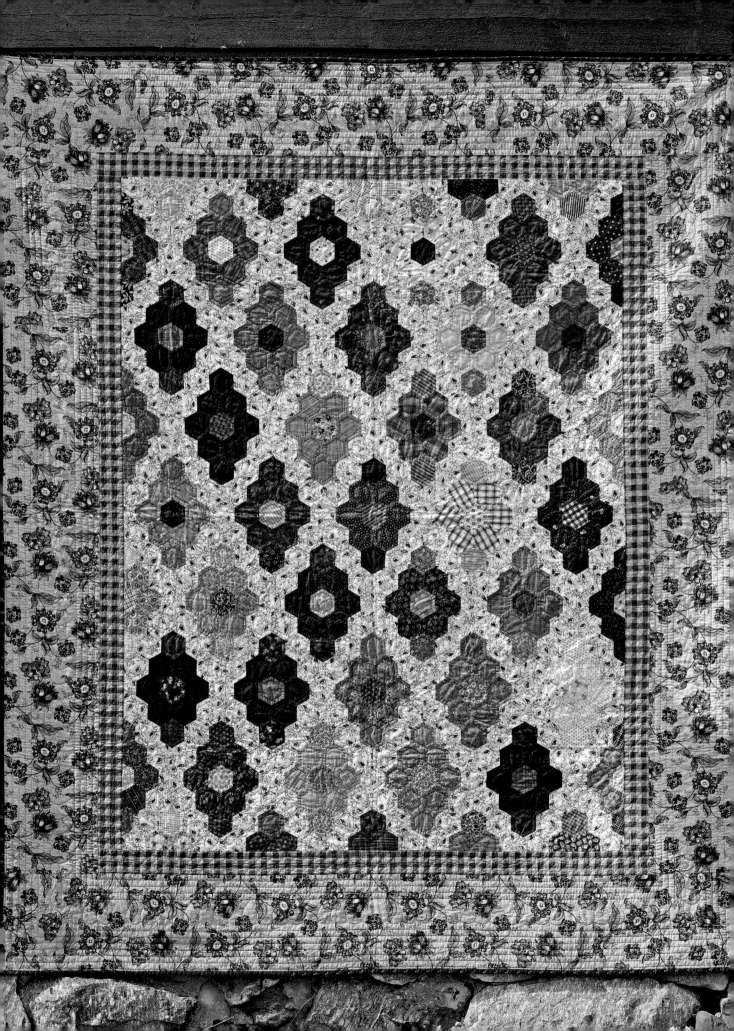

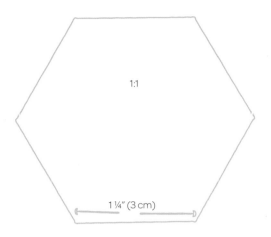

1:1

1 ¼" (3 cm)

Thoughts About Fabric Choice

The fabrics are mainly green and red. In addition, I have burnt orange, mustard, gray, brown, light purple, and black. And of course the important sashing fabric. It was hard to find. I began sewing the other fabric, but the impression was too flat and gray—for me. The fabric I finally found in the end is busy without predictable repetitions. The pattern is busy enough to highlight the other fabrics without getting too dominant. The frames are checkered and large-flowered. The border brings out the red colors from the middle piece.

Cutting Plan

If you have an acrylic template, please note: Cut strips of 3" (7 ½ cm) and cut based on the plastic template. Use the turning plate of a cutting board, if you have one.

A strip of 3" x 24" (7 ½ cm x 60 cm) folded into 4 gives 16 to 20 hexagons.

The Seam Work

Blocks: First, sew 31 regular flowers, then put on the top and base piece so that the flowers get a hat and neck and become a ginger snap shape. Put a lot of thought into varying color schemes. I've sometimes used remnants and didn't get blocks with normal color division. Hat and neck are mostly equal to a flower in rank. The center is mostly unlike the flower.

Look closely at the pictures.
Sew a starting piece of the sashing on 16 of the flowers, but not the two side pieces. See sketch. I repeat: This applies only to 16 blocks, not all 31.

Sew 8 half flowers to the long sides. See the picture.

Also sew 10 hats/necks to the short sides.

Filler Fabric

Lay out all of the blocks like the pattern in the picture. Be careful to distribute the colors over the entire blanket so you don't get a huge accumulation of red in one corner and green in another. Fill the background pieces of sashing where there are any gaps.

Frames

The frames are cut in widths of 2" and 8 ¼" (5 cm and 21 cm), respectively.

Quilting

The blanket is quilted by hand inside each hexagon, within the seam allowance. The checkered frame has a lattice pattern. For the flower frame, parallel lines are made that are broken by a half-straight feather. See sketch. The distance between the grooves is about 3/8" (1 cm). The grooves go all the way to the edge of the blanket. The hand quilting was done by Myrna Jeremiasse.

Border

The border is cut to 2 ¼" (about 5 ½ cm).

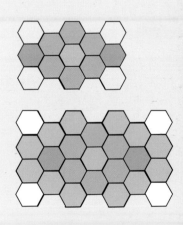

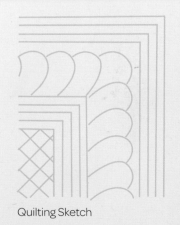

Quilting Sketch

9

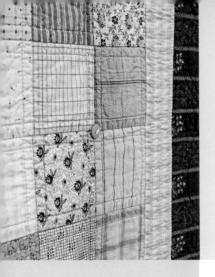

This quilt was in a competition where the theme was "My Inner Space." I replied that it could be buttoned up, which was symbolized by nine buttons scattered throughout the inner part of the quilt. The jury did not award a prize to my quilt—which, in itself, is not unusual when it comes to my color selection and interpretations. I myself think the quilt is great, and insist on continuing to participate in competitions. Perhaps my inner room is without introspection?

Buttoned Up

Materials

- 24" (60 cm) in total of diverse remnants into 36 squares, where each piece has to be at least about 4 ¾" x 4 ¾" (12 cm x 12 cm).

Frames:
- light pink inner frame, 16" (40 cm).
- brown-orange outer frame, 24" (60 cm).
- violet dice in the outer frame, 8" (20 cm).

Border:
- light blue border, 6" (15 cm) or more if you want to cut on an angle.

Backing and Batting:
- back panel and batting, 44" x 44" (110 x 110 cm).
- 9 light blue buttons.

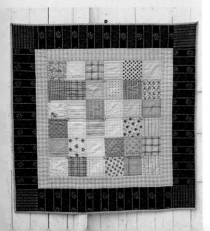

Cover of about 36" x 36" (90 cm x 90 cm) pre-washed and shrunk
Size of pre-sewn square: 3 ¾" (9 ½ cm)

Thoughts About Fabric Choice

All of the squares in the middle are tender and bright. They range from gray through beige, to pink, blue, and green. The frame is a striped and funny affair. Because it was difficult to get this material to meet well in the corners, I chose to put four dice in the frame.

Cutting Plan

Blocks:
Cut 36 squares of 4 ¼" (11 cm).
Frames:
light pink inner frame:
2 pieces 3" x 23" (7 ½" cm x 57½ cm).
2 pieces 3" x 28" (7 ½" cm x 70 cm).
Brown-orange outer frame:
4 pieces 5" x 28" (12 ½ cm x 70 cm).
Violet dice:
4 pieces 5" x 5" (12 ½ cm x 12 ½ cm).
Border:
Cut 2 ¼" wide (5 ½ cm).

The Seam Work

Lay out the squares in a beautiful display, and sew together 6 rows with 6 squares in each. Sew the rows together. Attach the upper and lower frame, and then the side frames.

Sew on the dice to two of the opposite outer frames.

Sew on the two other opposite frames, and the frames with dice after that.

Quilting

The inner space is quilted in each seam in addition to being quilted a foot's distance from each seam. The light pink frame gets three grooves with stitching that follows the stripes in the material. The surrounding frame is sewn with the help of Borders Made Easy no. 102 (the same as on "Ginger Snaps in Jane Austen's Direction," page 68). Toward the end, I've sewn on nine buttons for decoration in square land.

Border

Close by sewing on the border.

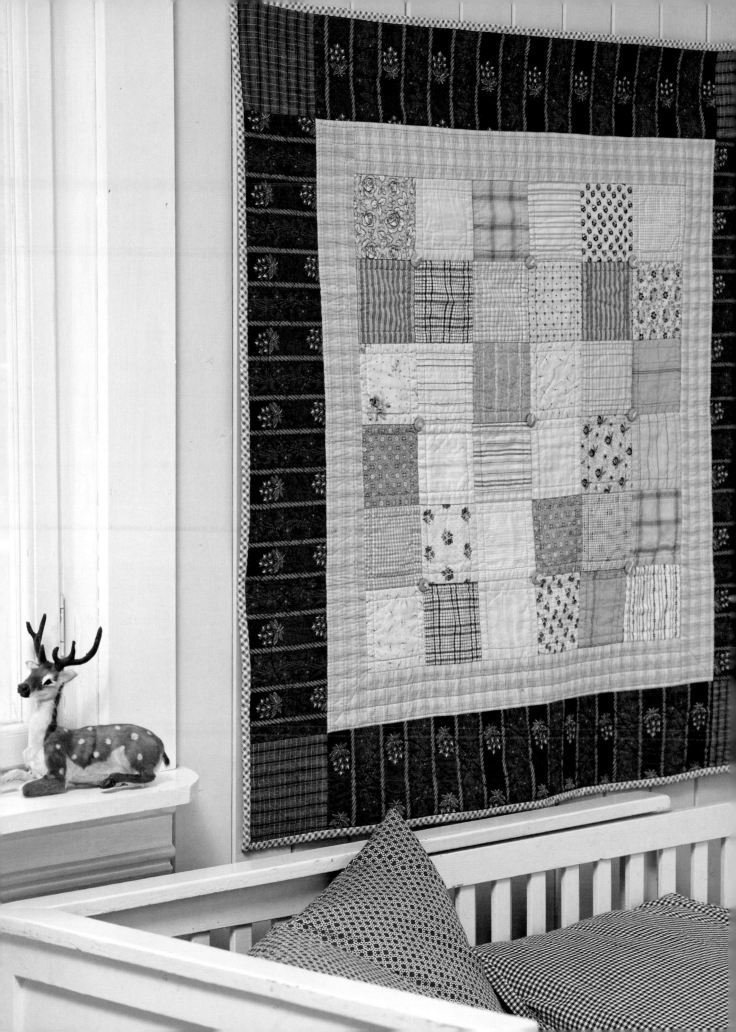

Another competition selection, this time with the theme "Joy of Quilting." Unfortunately, this jury was as difficult in its selection as the previous one.

Materials

Special equipment:
- Bands or bias tape for the floral wreath about 106.3" x ½" (2.7 m x 15 mm).
- Paper from Paper Pieces; Circles and Leaf.
- Pearl yarn for application.

For 4 blocks:
- star base, 12" (30 cm).
- star tags, 6" (15 cm).
- star tags, 6" (15 cm) If you want to sew 4 different stars, you don't need more than 4" (10 cm) for the base and tags. But then in return, you have to have several fabric variations, obviously.

Filler fabric between the stars:
- 16" (40 cm) for side triangles.
- 12" (30 cm) for corner triangles.
- 12" (30 cm) for the square in the middle.
- Filler fabric behind the applications (green-checkered) 20" (50 cm).

Fabric for the applications:
- 4" (10 cm) of a wide selection of fabrics, I have 40 different small pieces of each variant. There are 16 leaves and 24 flower buds (circles).

Frame and border:
- 30" (75 cm).

Back panel and batting:
- 50" x 50" (125 cm x 125 cm).

A Lot of Fun

A sprawling, vibrant tablecloth about 38" x 38" (95 cm x 95 cm) big, pre-washed and shrunk.

Size of pre-sewn sawtooth star blocks 8" x 8" (20 cm x 20 cm)

The Anatomy

Four halting and alienated sawtooth stars—so that you wonder if they belong in the same family—are put on edge inside of a square. This, then, stands on edge in a green-checkered material. The surrounding frame is brown-flowered. All of the colors are an attempt at harmony with the help of a flower wreath that is roughly and whimsically appliquéd on top at the end.

The stem in the wreath is a band. The

flower buds and leaves are made with the help of pre-cut cardboard.

Thoughts About Fabric Choice

Here, I've used playful materials in many colors like brown, orange, mustard, mint, sky blue, apple green, pink, black, and red. I have used both bright and chilling colors, and from careful to crude patterns. Particular color selections of mine were judged with the lowest grade possible from the jury's side. I strongly disagree. On the contrary, I think this blanket's color scheme is a result of bold combinations and the joy of quilting in practice.

Cutting Plan

Blocks:
For a sawtooth star.
Star bases:
4 pieces, 2 ½" x 2 ½" (6 cm x 6 cm), and
4 pieces, 2 ½" x 4 ½" (6 cm x 11 cm).
Star tags:
8 pieces, 2 ½" x 2 ½" (6 cm x 6 cm).
Star middle:
4 ½" x 4 ½" (11 cm x 11 cm)
cut for four stars.
Filler fabric between the stars:
A square of 8 ½" x 8 ½" (21 ¼ cm x 21 ¼ cm).

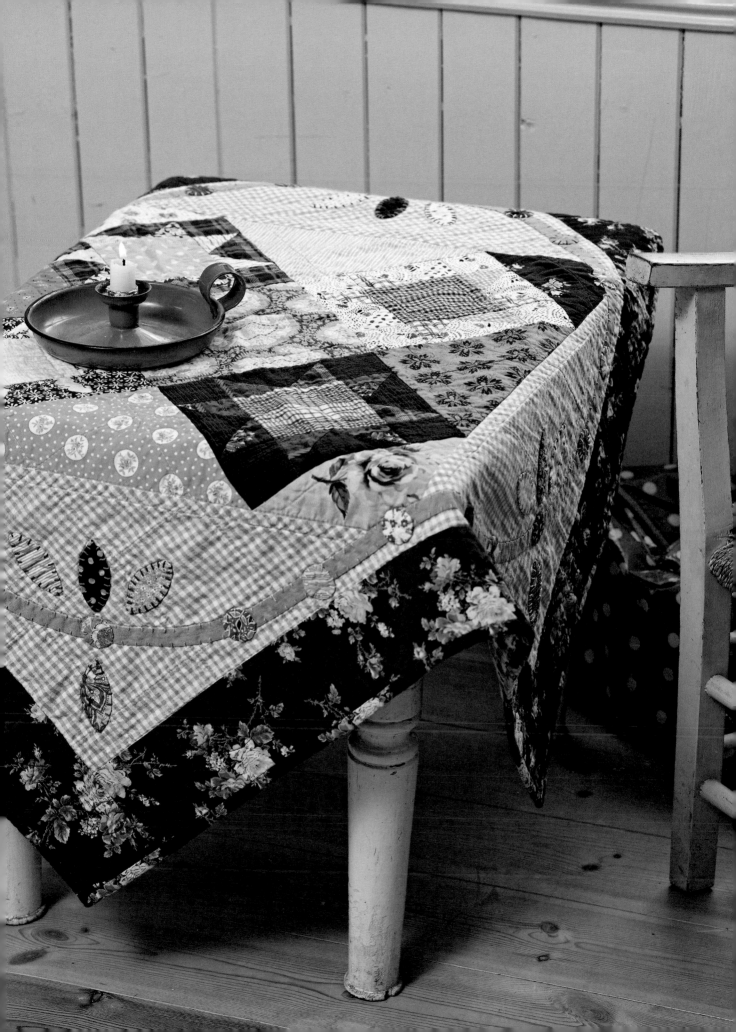

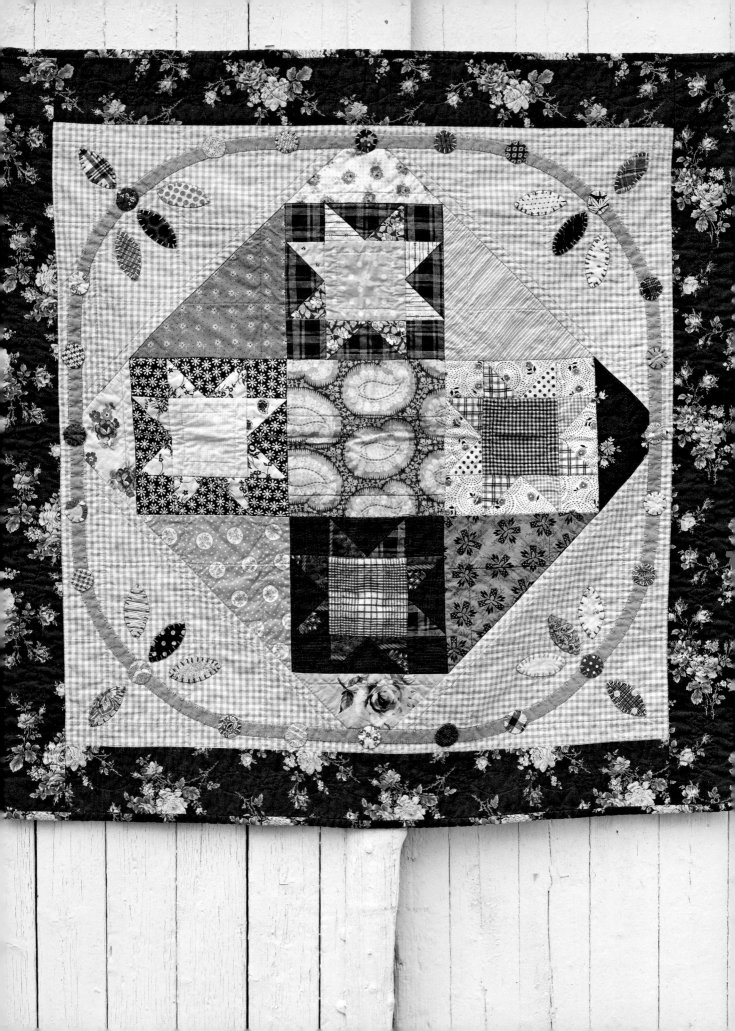

Two squares of 6 ½" x 6 ½" (16 cm x 16 cm) divided diagonally one time. These will be the corner triangles. If you want to have different materials in the corners, you have to use four different materials and accept that you'll have the half parts of the pieces left over.

One square of 12 ½" x 12 ½" (about 31 cm x 31 cm) divided diagonally two times, will be the four side triangles. If you want to have different materials, you have to use four different squares and use ¾ of the triangles for something other than this blanket here.

Filler fabric behind the applications:
2 squares of 16" x 16" (40 cm x 40 cm) divided diagonally one time into 4 triangles.
Frames:
Cut 4 ½" (11 cm) wide.
Border:
Cut 2 ¼" (6 cm) wide.

The Seam Work

Sew sawtooth stars with quick corners based on the sketch. Sew together the entire blanket based on the sketch.

Applications

One circle is appliquéd on the green-checkered material. The circle consists of a band that is sewn on with a rough stitch. Because the band doesn't make a curve shape from the start, it became a little difficult with the working process. There are better ways of appliquéing a wreath. For example, with bias tape and Vlisofix strips, or regular Vlisofix application. Or you can use twisted bands like you use for Baltimore applications. Choose a method you are proficient in. Fabric tape is actually not recommended, but if I should do it one more time, I would choose the same way of doing it, lazy as I am.

Prepare flower buds and leaves based on the description in the shaded field on the right. Distribute all of the portions throughout, and work carefully in between where the simple circles and leaves thrive the best. Appliqué them in place.

Quilting

It is sewn for all of the seams. In addition, you find a seam inside the star middle. Some of the triangles have a stitching along the longest side. The whole background—except for stars and flower wreath—are completely covered with a checkered pattern. The brown frame is quilted with Borders Made Easy no. 104 like on "Kitchen Tablecloth," page 64.

Border

I've chosen the same color on the border as the frame. It has to be a little quiet in a chaotic landscape like this.

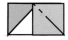

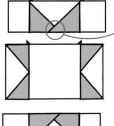

Make sure you have enough seam room here

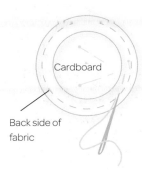

Cardboard

Back side of fabric

Secure a cardboard plate to the back side of the material. Cut out the material with about ¼" (½ cm) seam room. Tack around the edge. Tighten the thread and pull the fabric around the cardboard. Secure.

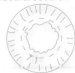

The back side of a tacked cardboard with fabric around it.

Iron with cardboard inside. Remove the cardboard.

Secure the fabric with a pin where you want to appliqué the circle.

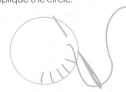

Appliqué with rough and simple stitching. Use pearl yarn in contrasting colors.

15

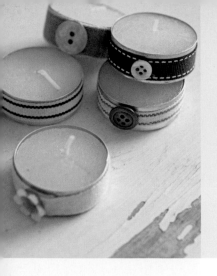

Sad tea lights are dressed up in style when the glue gun gets used. Think Easter, summer, or Christmas when you choose bands and buttons. Have both band remnants and buttons in easily accessible boxes, as well as the glue gun.

Sash and Bow Tie

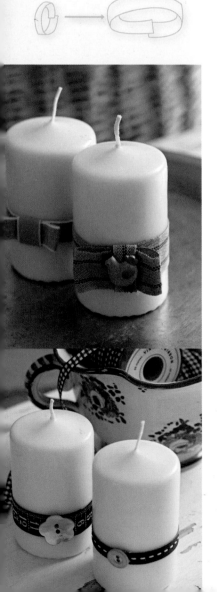

I've previously made candle holders directly on candles. If you just glue the band to itself in a ring (and therefore not secure it to the candle), the band can be removed and used again. It was my daughter, Marie, who introduced the tealight holder as an alternative. When the material lies out over the living room table for a few days, kids end up sitting down to make a few as well. A band that is glued securely to the tealight holder cannot be used again, but it can be used with the metal. You put a new candle into the metal holder when the candle is burned entirely out. If there's candle residue left, remove it while the candle is warm. Or you can also make as many candles as you can for entryway use. Easter in the mountains without electricity, and late hours on the glass veranda in the summer, get especially extra cozy with such delights as lighting points. It's a great hostess gift.

Trim a band end, put a pearl of red-hot glue on the tea light holder, and press the band down without burning the fingertips. Tighten the band around the whole thing, and let it overlap a little. Put a drop of glue on the newly secured band

end, and tighten the band ring around the tea light holder. Cut the end right off. Put another drop of glue on the band and press a button on the top. First, I secure the band on some tea light holders, and then I sit for a while and test which button lifts the completeness.

Bow Tie

Glue together a circle of band. Press it flat and place the cut in back. Glue a new band ring over this as a visual knot, in that you place the cut in back. Glue all of this on top of the band again.

Opposite

Glue a circle of ribbon. Squeeze it flat, and place seam behind. Glue a new ribbon circle over this as a visual knot as you place the joint between them back. Glue all this on top of the ribbon again.

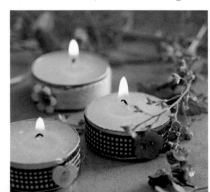

Have you heard that scratches on the legs can be called "summer flowers"? They at least appear this way, it's said. I learned that from a lady named Greta. In long, warm summers with a lot of playing, you end up with a lot of scratches—or, therefore, "summer flowers." Every time I see a scratched-up leg, I think about Greta's summer flowers. This little cover with 9 flower blocks is named after her word play.

Greta's Summer Flowers

Materials

Material for 9 blocks:
- 36 different fabrics for petals (small pieces of 4"/10 cm is good).
- 9 different flower centers (small pieces of 2 ½"/6 cm holder).
- 9 different base pieces, 6" x 6" (15 x 15 cm) of each material is sufficient.

Frames:
- light blue striped material, 4" (10 cm).
- corner dice for light frame, 4" (10 cm).
- brown fabric, 8" (20 cm).
- corner dice for dark frame, 4" (10 cm).

Border:
- brown checks, cut on an angle, 20" (50 cm).

Backing and batting:
- both back panel and batting are cut 32" x 32" (80 cm x 80 cm).

The cover measures about 13 ½" x 13 ½" (56 cm x 56 cm) pre-washed and shrunk
The size of a pre-sewn Dresden Plate/summer flower block on a background: 4 ½" (11 ½ cm)

The Anatomy

The cover is set up with 3 x 3 blocks, 9 pieces altogether. In each flower, 2 and 2 petals are sewn from the same fabric. Each flower will have 4 different fabrics, 2 petals in each fabric, 8 petals altogether. Two light fabrics and 2 dark fabrics are chosen for each flower.

Special Equipment

I've used pre-cut paper templates (Miniature Dresden Plate) for the flower applications. If you can't obtain the plates, you have to cut them out of cardboard yourself. If you pre-sew flowers one at a time, you come up with 8 petals and a circle. The cardboard can be used several times.
The measurements are 1" and 1 ¼" (2 ½ cm and 2 9/10 cm).

Thoughs On Fabric Choice

For the application bases:
Quiet fabrics with checks, dots, and stripes in both light and darker tones.

For the flowers:
Light shirting with print in green, yellow, brown, blue, and lilac. Moreover, plaid in different sizes and colors. In addition, historical fabric in varying shades of color and types of patterns.

Cutting Plan

Blocks:
Application bases. Cut 9 pieces of 5" x 5" (12 7/10 cm x 12 7/10 cm).
Frames:
The light-striped frames (4 pieces) are cut 2" x 14" (5 cm x 35 cm) 4 small corners are cut 2" x 2" (5 cm x 5 cm).
The brown frame (4 pieces) is cut 3 ¼" x 17" (8 cm x 42 ½ cm wide) followed by 4 big corner squares cut to measure 3 ¼" x 3 ¼" (8 cm x 8 cm).

The Seam Work

The same technique is used here as when you sew the Danish/English way over cardboard, see "Dresser," page 26. Cut out pieces of fabric by free hand in that you add a seam allowance. Hold a piece of cardboard securely on top of some fabric, and cut around while you hold the piece of cardboard in the same

18

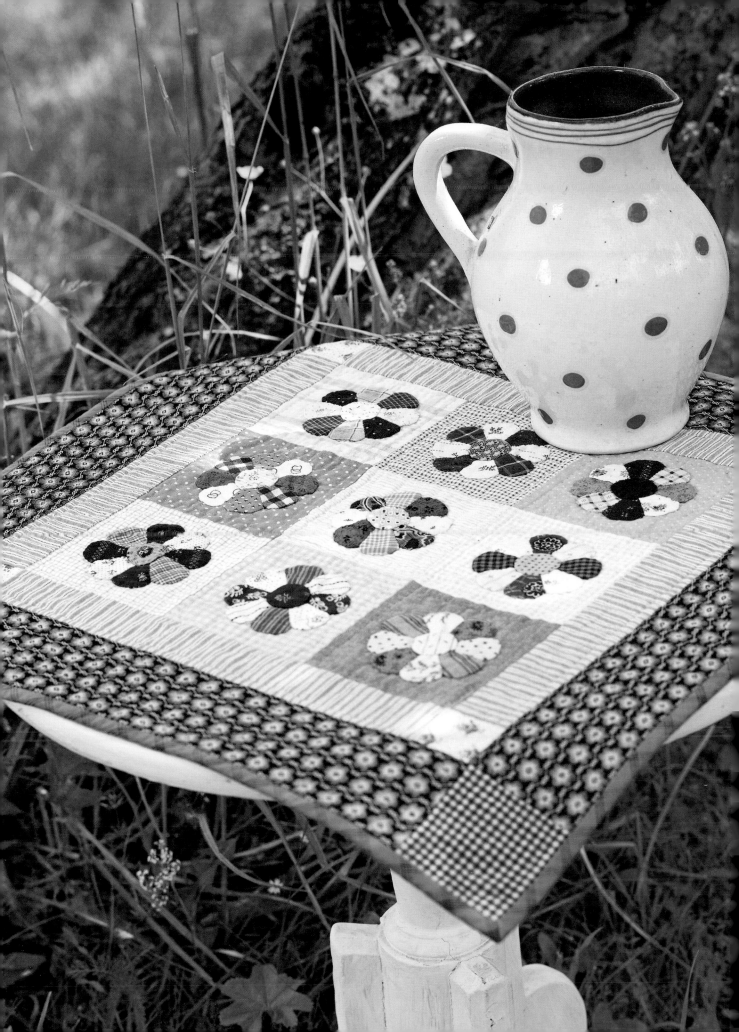

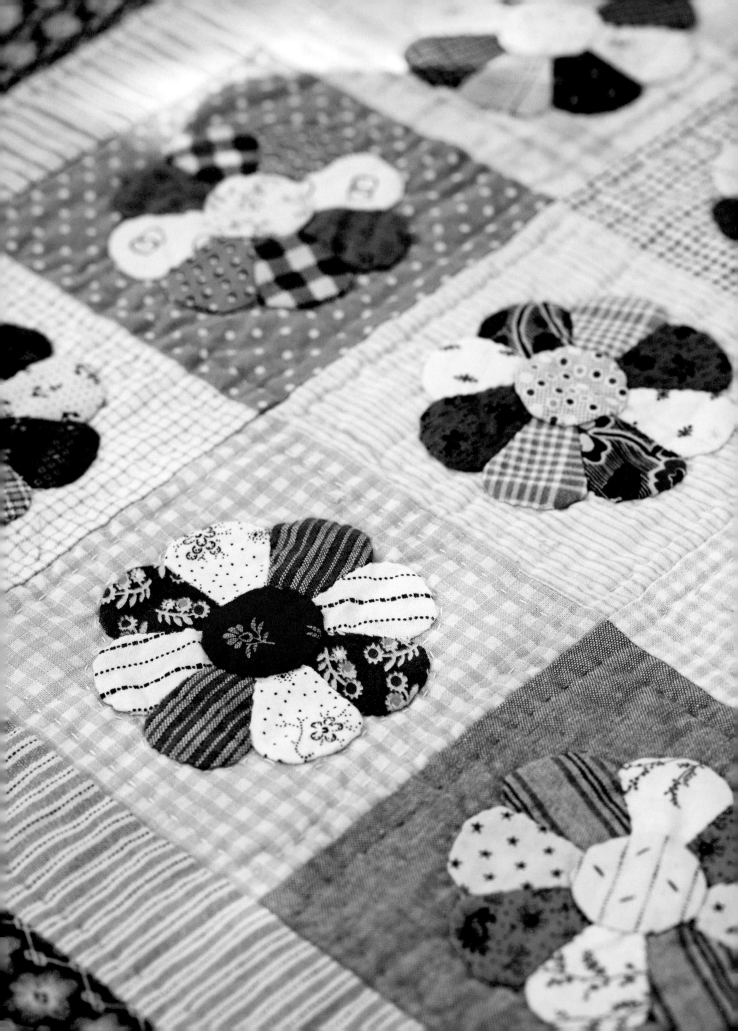

place. The piece of fabric will be bigger than the piece of paper. The seam allowance will go around the paperboard. Use thread for tacking. Then it's easier to take off the tacking stitches afterward without cutting away important knots that should have been there. Begin with a knot and sew a shrinking stitch in the curve. Put the cardboard against the back side, draw the shrinking together, and hold securely. Tack zigzag from side to side until the cardboard is trapped inside the fabric. Make sure that it gets tight and smooth.

The circles for the middle of the flower will also be tacked. See "A Lot of Fun," page 12. The fabric circle is tacked the entire way around before you tuck a paperboard piece in and tighten.

Arrange the flowers so that every other petal is light and dark. Petals directly across from each other have the same fabric.

Sew together petal sides with matching thread into a circle of 8 leaves. The side seams are sewn by holding two petals against each other, right side against right side, with the curves exactly on top of each other. Choose colors of thread based on the darkest material and keep this toward you while you sew small throwing/tucking stitches so that the right side is sewn together. Secure well with the starting and closing ones. See "Eight Petal Rose in Original Transfer," page 94.

Now, each of the flowers will be appliquéd down on its own piece of fabric of 5" x 5" (12 ½ cm x 12 ½ cm). Fold and stroke the 5" x 5" (12 ½ cm x 12 ½ cm) backgrounds to the applications two times so that you get good guide marks when you go to place the flowers on them. Notice that it's cut between two petals that are suitable guide marks, and not the petal's middle line. The flowers are secured to the application's underside with button pins and then appliquéd down on the base. I have used invisible hand application and thread similar to that for the petal. That means securing a new thread color with each petal. See "Dresser," page 26.

Cut away the material under the flowers to take out all of the cardboard. Throw away the tacking stitches. Now you'll understand the need for disposable thread for tacking. It's easy to remove because it lights up. It isn't fun to cut away seams or knots that actually should be kept.

Quilting

It is quilted around each flower and with the seam allowance's distance within the square that the flower is appliquéd on. The frames have stitches parallel to the seams in the pattern.

Border

Cut the border 2 ¼" (6 cm), fold twice lengthwise with the right side out, sew it on the machine from the right side, and fold around to the backside where it's sewn securely by hand.

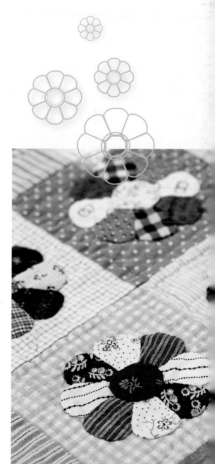

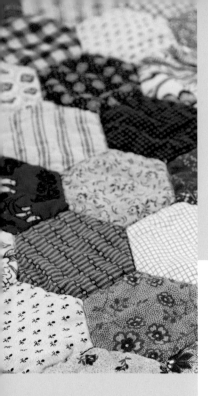

After "Grandmother's Living Room Wall" was well in port, I had all kinds of pre-cut hexagons left—which I still have! These "wallpaper remnants" of some hexagons were supplemented with new fabrics. I added several varieties of corn-blue and light fabric.

Wallpaper Remnants by Rank

Materials

- At least 45 different hexagon fabrics, about 14 ½" x 4" (36 cm x 10 cm) of each fabric (I calculated 4 of the same of each fabric).

Frame:
- about 44 ¼" x 14" (111 cm x 35 cm) of white-and-blue-checkered fabric.

Border:
- about 10" (25 cm) of red fabric.

Backing and batting:
- about 50" x 28" (125 cm x 70 cm).

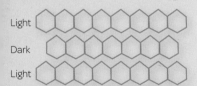

Light
Dark
Light

Sew strips, then sew together lengthwise afterward.

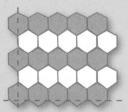

Seam lines when placing the frames.

Runner about (119 cm x 56 cm)
Size of pre-sewn hexagon is 1 ¼" (about 3 cm)
(measured along one of the six sides)

The Anatomy
The runner consists of 20 x 9 hexagons, 180 hexagons in total. All of the edges of the hexagons are trimmed so that it is easy to sew the frames with the machine. Each vertical strip is either dark or light, and they are put together in an alternating pattern.

Special Equipment
Paper Pieces 1 ¼" Hexagon, see also "Grandmother's Living Room Wall," page 6.

Thoughts about Fabric Choice
I used leftovers from "Grandmother's Living Room Wall," page 6, and added corn blue in light and dark. Altogether, there are a variety of light shades: white, beige, light blue, pink, and bright green. The dark ones range from bright blue, bright red, brown, warm green, and mustard.

Cutting Plan
Cut out 180 hexagons from the template on page 9 including the seam allowance. 80 should be light and 100 will be dark.
Frames:
The long sides are cut 3 ¼" wide (about 8 cm).

The short sides are cut 2 ¼" wide (about 6 cm).

The Seam Work
Sew light strips together, 20 hexagons directly below each other. Do 4 strips.

Sew dark strips after that with 20 hexagons. There are 5 dark strips used in the model. Cut the cardboard you're using for the outer edge.

Lay out the strips for the pattern by alternating light and dark. It will be an uneven edge on top and bottom (and, of course, the sides). Sew the horizontal seams between the 20 light ones and 20 dark ones. Remove the cardboard. Trim the edges, and put on the frames. Alternatively, you can cut the cardboard while sewing.

Quilting
The model is quilted into each seam around each hexagon. The frame is quilted in a striped pattern, suiting the checkered pattern in the material, at about ¼" (7 mm) intervals.

Border
The border is cut 2 ¼" (6 cm).

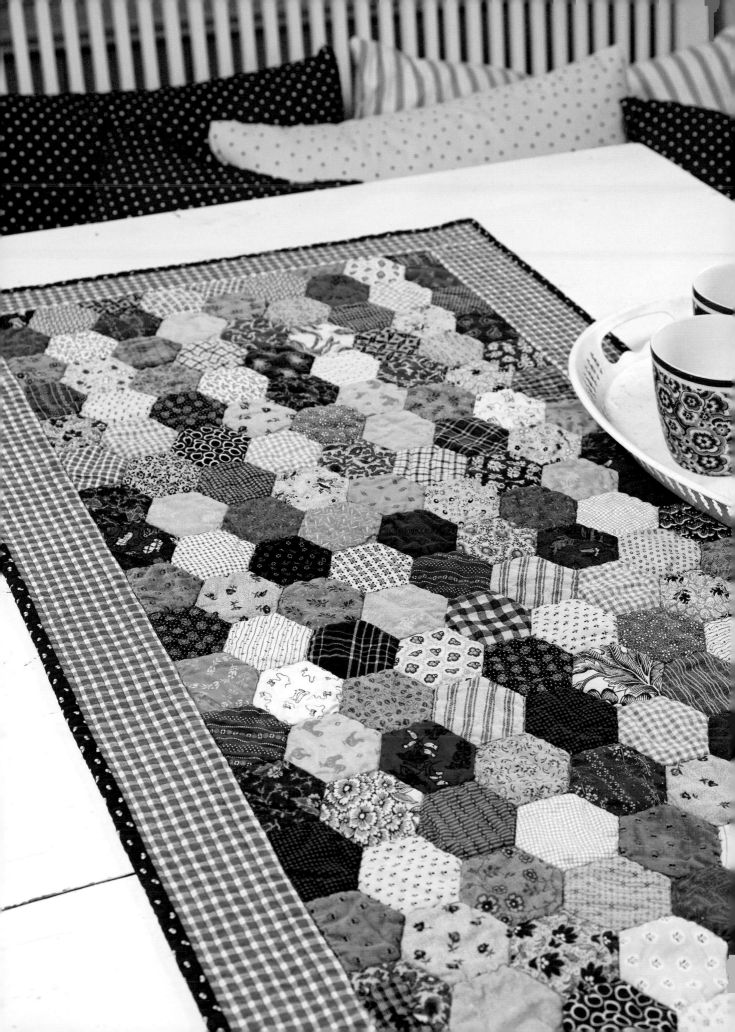

This is fun work that ends up as a little gem of a mini-quilt. It can be customizable vacation craftwork when one is without a sewing machine. I have used hand sewing over pre-cut cardboard a size of ½" (about 1 ½ cm).

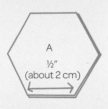

A
½"
(about 2 cm)

Materials

For the hexagons:
- 66 tiny pieces of fabric remnants of 2" x 2" (5 cm x 5 cm). Save them in a separate box.

Frame:
- 16" x 14" (40 cm x 35 cm) striped bright blue fabric.

Wool batting and back panel:
- 16" x 14" (40 cm x 35 cm).

Border:
- 6" (15 cm) red fabric.

Special equipment:
- templates from Paper Pieces ½" (about 1 cm) hexagon.
- good silk thread for hand sewing in, for example, three shades of gray.
- good, thin needles, for example, Hand Appliqué.

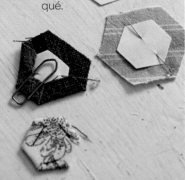

Hexagons in Anarchy

Tile or bedspread cover about 9 ½" x 12 ¾" (24 cm x 32 cm)
Size of pre-sewn hexagon is ½" (1 ³/₁₀ cm)
(Measured along one of the six sides)

The Anatomy

The blanket has 4 rows consisting of 9 hexagons and three rows consisting of 10 hexagons, which equals 66 hexagons together. There is no system for how the colors are added—it's like the blanket's title says: anarchy.

The Seam Work

Attach a piece of cardboard on the wrong side of a fabric. Cut out exactly a ¼" (about ½ cm) seam allowance on all sides. Fold the seam allowance tightly over the cardboard, and tack it in place. I often use a paper clip to help to keep the seam allowance in place while I tack. Make sure you remove the paper clip when you're done tacking.

Compose the surface while sewing. Distribute dark and light pattern types and colors evenly throughout.

Hold two cardboard plates right sides together and sew them together at the top along one side with small throwing stitches by hand. You'll just nip in the fabric so the cardboard is not included.

When a hexagon is completely surrounded by other hexagons, you can take away the tack thread and remove the cardboard. It can be reused. For the outer edge, the cardboard has to sit still for a while.

Assembly

The finished middle section is appliquéd to a whole piece of fabric that forms the frames. Place the finished hexagons down on the right side of the frame fabric. Tack the hexagons to the frame material. Make sure that everything is flat and straight. Appliqué around the whole thing with small invisible hem stitches (see page 29).

Cut away the striped fabric that is the middle section, but save seam space along the application's seam allowance. Remove the last paper hexagons.

Quilting

Add batting and backing behind the front. Tack together and quilt. All my

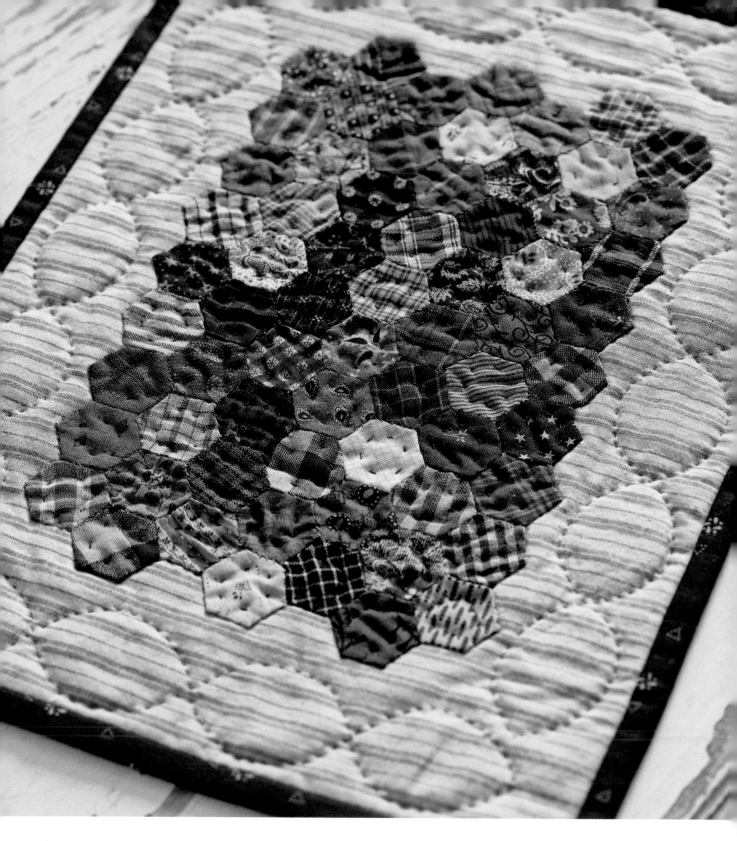

hexagons have a stitching allowance distance from the edges. Moreover, a single cable board is made on the frame.

Border

Trimmed 2 ¼" (5 ½ cm) wide. It is selected in red to collect the piece into one kingdom.

Start long side

Start short side

About 1 ¼" (3 cm)

25

Application and hand sewing over pre-cut cardboard was performed over several years, on countless holidays. It's the perfect travel companion. Note that the application is actually tailored to a base of 12" x 12" (30 cm x 30 cm), but I have chosen to make my base a little higher for visual reasons. The block is a perfect circle and not an oval, even though the base is rectangular and not square. The block is called "Dresden Plate" in English. I have christened it "Porsgrund Porcelain" in Norwegian.

Dish Rack

Materials

For 12 blocks:
- 12 different fabrics for the base about 14" x 14" (35 cm x 35 cm), together 59" (1 ½ m).
- 192 different petal fabrics of about 5 ¼" x 2 7/8" (13 cm x 7 cm), a total of around 98 ½" (2 ½ m).
- 6" (15 cm) gray fabric for circle in the center of each block.

Filler fabric and frames:
- 79" (2 m) light fabric with orange pattern for block framing (alternatively, 55"/1.4 m, if you want to cut).
- 102 ¼" (2.6 m) light blue fabric for outer frame.

Border:
- 19 ½" (½ m) striped olive-colored fabric.

Backing and backing:
- about 92" x 74" (230 cm x 185 cm).

The blanket measures about 83 ¼" x 64 ¾" (208 cm x 162 cm) pre-washed and shrunk
Size of pre-sewn block:
Width 12" x height 13" (30 ½ cm x 33 cm)

The Anatomy:
The blocks are a little higher than they are wide, and they are stacked in three heights. Each bar is separated from the other with bright orange fabric. The surrounding frames are wider at the top and bottom. This is how the blanket got a rectangular shape even though the block at the starting point is really square.

Special Equipment
Pre-punched cardboard from Paper Pieces for Dresden Plate/Porsgrund Porcelain, a package of cardboard plates for 12 dishes that are suitable for bases a size of 12" to 14" (30 cm x 35 cm). The package contains 16 petals to 12 blocks, a total of 192 petals. Moreover, there are 12 circles for the middle.

Thoughts about Fabric Choice
All 12 blocks with 16 different fabrics were selected before I began to sew. It is important that each dish has both light and dark fabrics. They are in all colors and all patterns. When I decided to include violet, for example, I was careful to include several nuances and several patterns. Each violet fabric was distributed over several blocks so that you see violet all over the blanket and not just in one flower. The trick is to make each flower beautiful and participate in the entire blanket's chorus of colors. The bases are generally bright and light—they are also in many colors and patterns. In several places, I had to cut because I didn't have pieces big enough. The block framing are bright in the same way the frame is. The border is relatively dark.

Cutting Plan
Block:
Clip 12 bases of 12 ¾" x 13 ½" (32 cm x 34 cm) in different light fabrics.

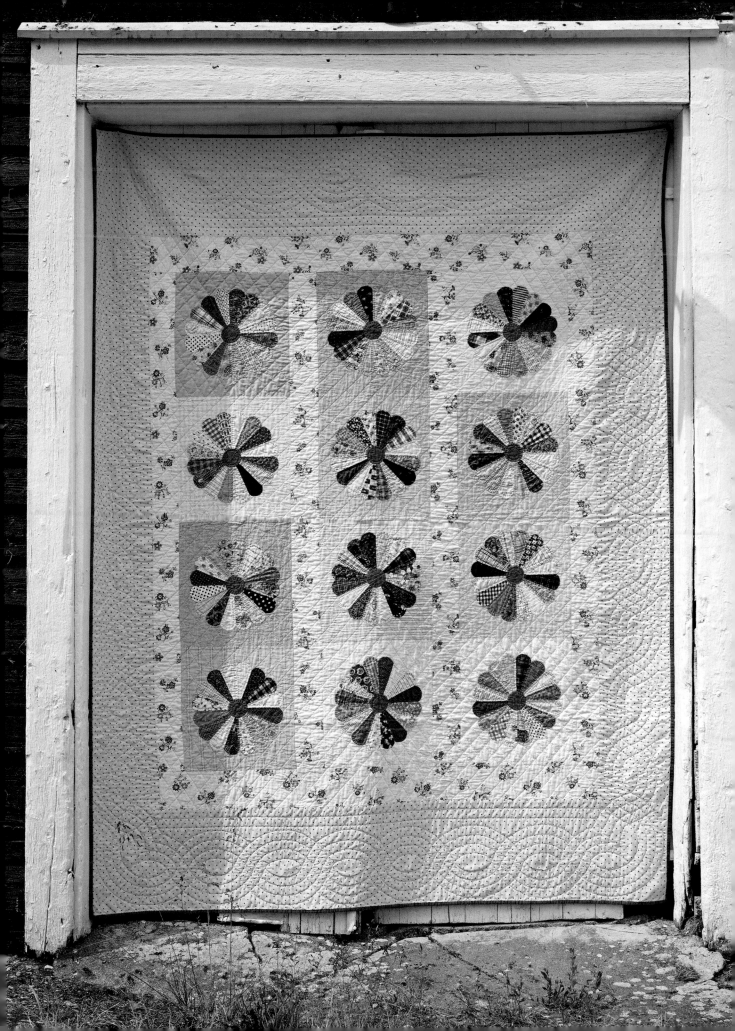

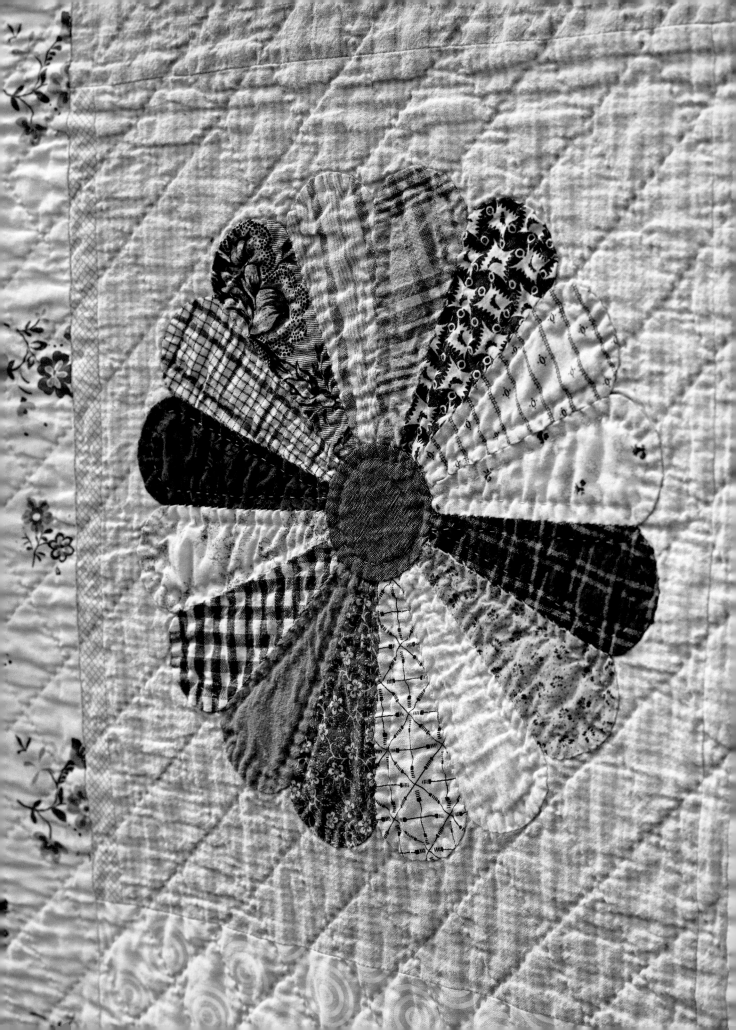

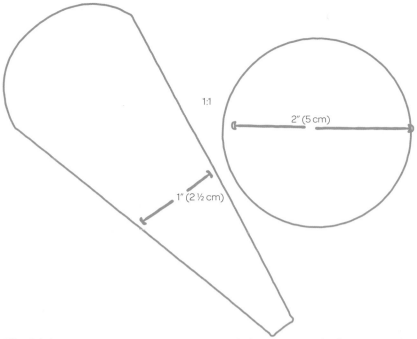

1:1

2" (5 cm)

1" (2 ½ cm)

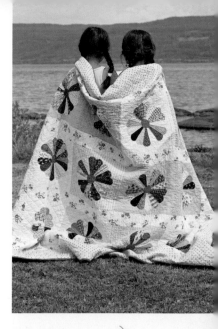

Invisible hand application

Quilting sketch

Filler fabric:
Cut 4 vertical block framing of 3 ½" x 52 ½" (about 9 cm x 131cm) in bright fabric with orange.
Flowers:
Cut 2 horizontal block framing of 4 ½" x 48 ½" (about 11 ½ cm x 121 cm).
In the same fabric
Frames:
Cut 2 vertical frames of 8" x 60 ½" (about 20 cm x 151 cm) in light blue fabric.
Cut 2 horizontal frames of 11 ½" x 63 ½" (29 cm x 158 ¾ cm) in the same fabric.

The Seam Work

Start by creating cardboard templates for original drawing (or purchase a package). You need 16 petals and a circle. Tack the fabric onto the template: I tack and tighten the curve before I put it in the cardboard. Then I tack across the back, back and forth, in order to catch the sides. Use a diverting thread for tacking, because it's easier to remove the tacking later on without cutting off an important knot that should be there. Begin with a knot and sew shrinking stitches in the curve. Place the cardboard on the back side, pull the shrinking together, and hold securely. Tack zigzag from side to side until the cardboard is trapped inside the fabric, tight and smooth. See the pictures.

Use hand sewing over cardboard for sewing the leaves together along the sides. Fold the base in half lengthwise and crosswise, and use ironing guide

marks in order to put the flowers exactly on the base. Since the height of the base is larger than the width, the flower gets more air on the top and bottom than on the sides. Tack the entire flower dish down on the base, or secure the blocks with safety pins. Sew flowers by appliqué with invisible stitches in the entire outer edge. See sketch and photo of the back side of an application seam around a curve. Sew the center circle in the same manner with invisible application. (See "A Lot of Fun," page 12, when it comes to the circle.) Trim the base fabric beneath the flower and remove the tacking and cardboard. Trim the seam allowance.

Quilting

The beautiful hand quilting was performed by Anne Fjellvær. The blanket has been given a full lattice pattern over the base and filler fabric. The flowers are quilted with one seam allowance away from all seams. See the sketch. The border has a cable pattern from a purchased plastic template. Since the frame on top and bottom is wider than the frame on the sides, we've added two straight seams to fill the gap. In addition, we took away the outermost row with cable work on the narrow sides. To be honest, we spent several days to hatch this out and draw it up.

Border

The olive green fabric is cut 2 ¼" (5 ½ cm).

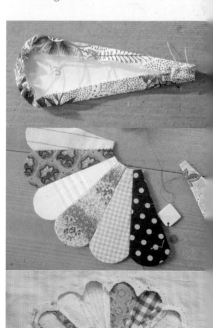

I have held some courses for the series "In Secret," which starts with me selecting fabrics and a block. Each course participant MUST use the fabrics and the block in their blanket. Furthermore, the participants can add what they desire of fabrics and blocks. There are no rules for how large, how many, or what method. It's fun to stay at home, in all secrecy, between course days. Everyone has the pleasure of seeing what the others have sewn in their own way since the last time they met. The course is stretched out over time, and the result is an exciting journey in the process for all course participants, right up to their own quilt compositions. As a course leader, I also throw myself into the game. This quilt is one such game from the time we all sewed rosebud blocks. I have also used blocks from an offer on the Web, organized by Helene Juul, in Denmark.

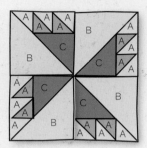

Materials

For 12 blocks, if they're sewn of the same fabric and not varied like I've done:
- 40" (1 m) bright base fabric for the largest and smallest triangles, A and B.
- 20" (½ m) dark fabric for the medium-size triangles, C.
- 12" (30 cm) otherwise dark fabric for small triangles, A.

Filler fabric:
- 40" (1 m) striped green and beige fabric for lattice workstreets.
- 12" (30 cm) pink fabric for dice in the lattice work.

Frames:
- 84" (210 cm) gray beige fabric for first frame.
- 34" (85 cm) dark brown fabric for frame on the top and bottom.

Border:
- 20" (50 cm) light blue fabric.

Backing and batting:
- about 84" x 64" (210 cm x 160 cm).

Rose Bud in All Secrecy

The quilt measures about 73 ¼" x 58 ¾" (183 cm x 147 cm) pre-washed and shrunk
Size of pre-made rose bud block 9" (about 23 cm)

The Anatomy
The blanket consists of 3 x 4 rose bud blocks with lattice-work streets between blocks and dice in the street intersections. The frame solution is unconventional because I had too little of the fabric that is sewn at the very top and very bottom.

Thoughts about Fabric Choice
There is great variation in color and fabric patterns within each block. Both of the bases, the lattice-work streets, and the frames are very quiet.

Cutting Plan
You get marks by templates with pre-sewn size for hand sewing as well as a cutting plan for machine sewing. Choose the way you like most. I've hand

sewn some of the blocks and machine-sewn others.

Blocks:
A: Cut a square of 2 3/8" x 2 3/8" (about 6 cm x 6 cm) and cut it diagonally to make 2 pieces of A. Each block requires 12 pieces of A-patches for the base fabric and 8 pieces of A-patches for the rosebud fabric.

B: Cut a square of 5 3/8" x 5 3/8" (about 13 ½ cm x 13 ½ cm) and cut it diagonally once to get 2 pieces of B. Each block requires 4 pieces of B-patches for the base fabric.

C: Cut a square of 3 7/8" x 3 7/8" (about 10 cm x 10 cm) and cut it diagonally once to get 2 pieces of C. Each block requires 4 pieces of C-patches for the rose bud fabric.

Filler fabric:
Lattice-work streets are cut 9 ½" x 3 ¼" (about 23 ¾ cm x 8 cm). You need 31 pieces.

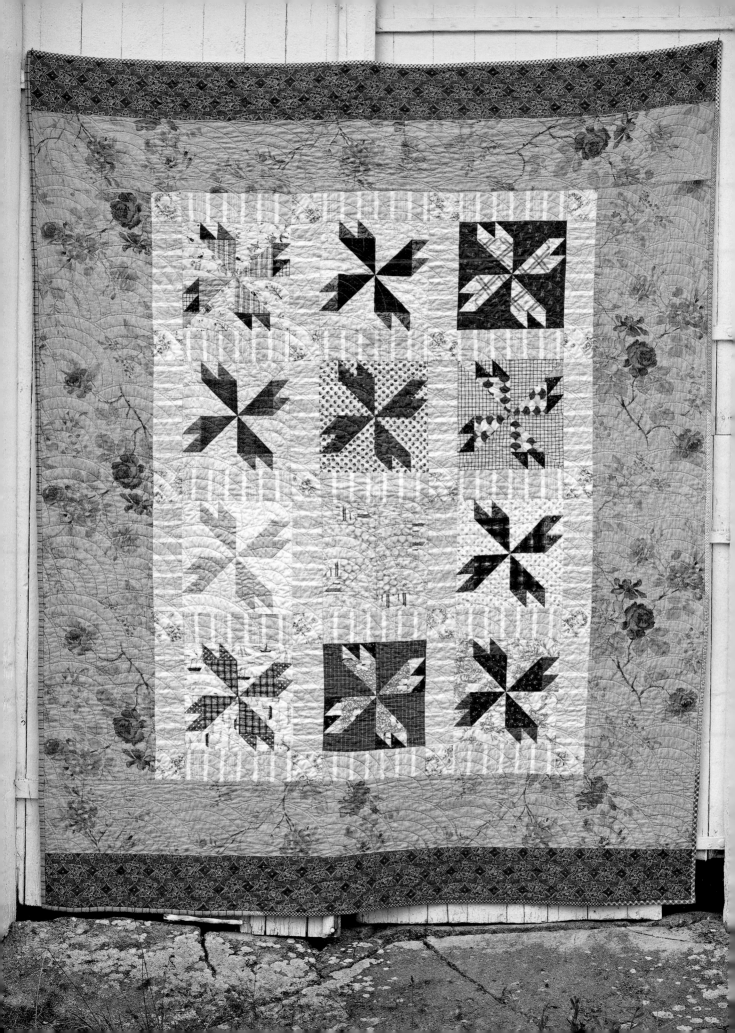

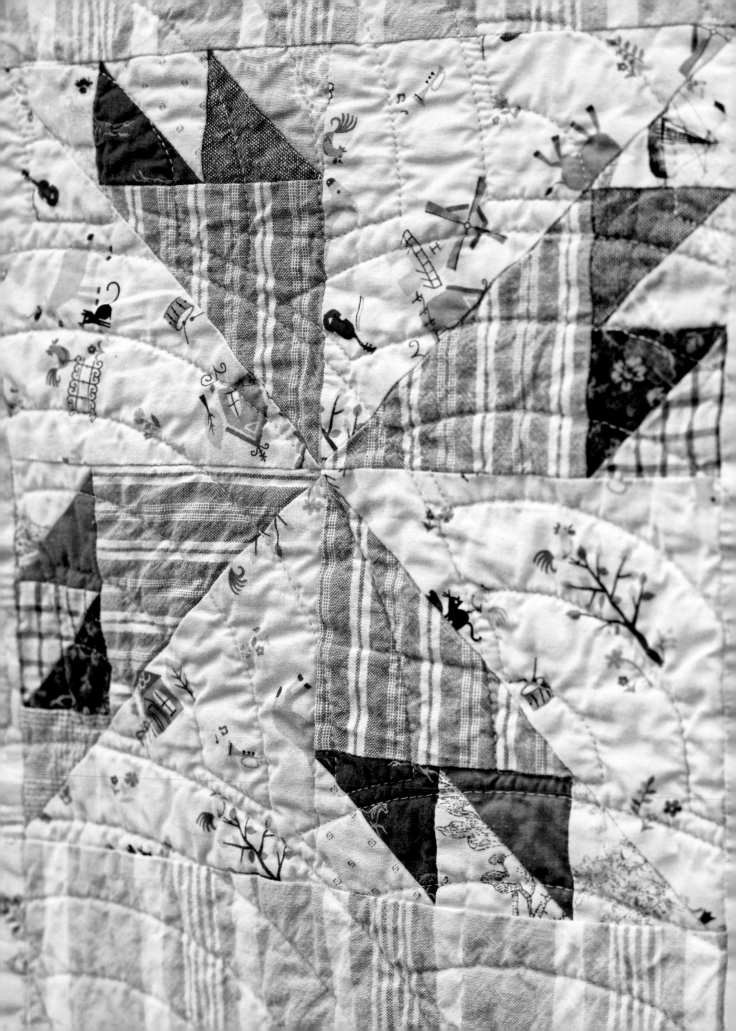

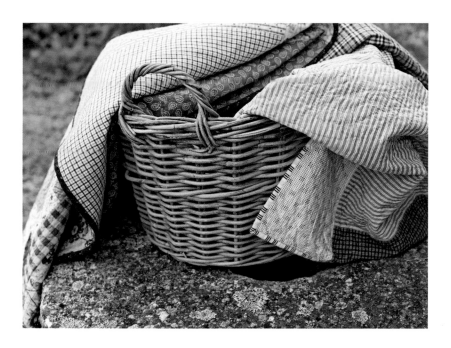

The dice are cut 3 ¼" x 3 ¼" (about 8 cm x 8 cm). That's 20 pieces.

Frames:
Vertical. 2 pieces at 50 ¼" x 10 ½" (about 125 ½ cm x 26 ¼ cm).
The first horizontal frame:
2 pieces at 58 ½" x 7" (about 146 ¼ cm x 17 ½ cm).
Other horizontal frame:
2 pieces at 58 ½" x 5 ½" (about 146 ¼ cm x 13 ¾ cm).

The Seam Work

Sew a fourth of the block at a time. Follow the sewing scheme. The figures indicate seam rows.

Sew four of these elements together to an entire block. Make sure you rotate them correctly. I attached a small drawing of the block in front of me to remember how the block looks. It is easy for the blocks to suddenly spin out of the pattern, this can happen to anyone at any skill level. Sew the blocks and parts of the street-lattice work in rows as the sketch shows. Sew the rows together. Sew on the frames based on the sketch.

Quilting

Merete Ellingsen, of www.sy.no, has machine-quilted the blanket with a solid fan pattern for me. It's fine to pay others for help with your blanket, this way you can minimize your trouble and still be happy finishing a blanket. I recommend the procedure if you generally struggle to get your blankets quilted. See quilting sketch for "Eight-Petal Rose in Original Transfer," page 97.

Border

I have dug down in my collection of border remnants and found good blue fabrics that are cut together to form a piece that is long enough. They are cut 2 ¼" (about 5 ½ cm) from the start.

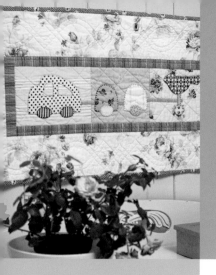

Here, I put away everything I've learned about perspective and proportions and instead will bring out the child in me by appliquéing simple and naive forms by hand. The rough, sloppy, beautiful, and invisible application stitch is used. The surface is built up little by little. If something exciting is missing in a corner, then I just sew a square piece of cloth in a fun pattern right there.

Naive Application by Method of Association

These applications are put into frames, therefore I do not think about pretty back panels or laundry-friendliness. This is picture making with thread and fabric—certainly not a patchwork quilt to be used as a bedspread or cover.

Ingri Juul, Cecilie Dedichen, and Janet Bolton have taught me basic embroidery and appliqué sloppiness. The joy of form and the desire to shape is more important than decorative stitches. Deliciously liberating! Training and literature from these ladies' hands are recommended.

You start by creating a surface for the application. It may be folded-up dish towels, old embroidery, shirts, tablecloths, bolsters, or just a piece of fabric. For the latter, it's good to work in an embroidery frame. If I make a little more compact application background with more layers of towels and fabric pieces on top of each other, I think it's best to work without an embroidery frame.

Then you need something that can give you form inspiration: a toy car? A scrub bucket? A miniature vase? A box of metal screws and nuts? Buttons or heirlooms in embroidery? A poster or ad with nice shapes? I even have a motorcycle ad that will be a wall picture soon. Perhaps a picture of the boat or cottage, or your first Moped? Rinse photos? The flora in color?

Choose one of these inspirational things—for example, the scrub bucket. Put it in front you, and let it be your application template. Make a list on a sheet of paper with words that belong to "scrub bucket." These very things are a good social or family activity. Let friends and family be allowed to associate freely around the word "scrub bucket." Write down the all the words without thinking about whether you can appliqué them. Use the list as inspiration while sewing. When the bucket is pre-appliquéd, you can continue to fill the space with help from the list: long brush, abrasive cloth, Ajax, wash cloth, scrub brush, green soap, and the radio on full

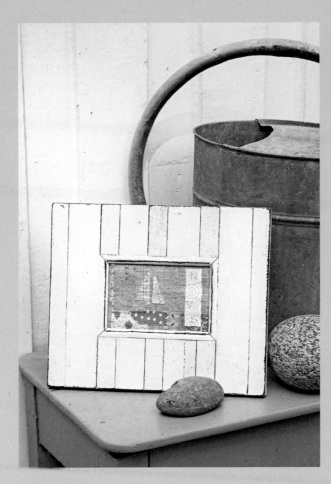

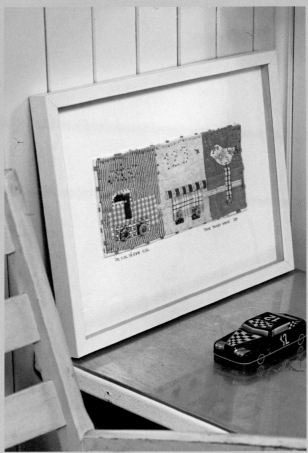

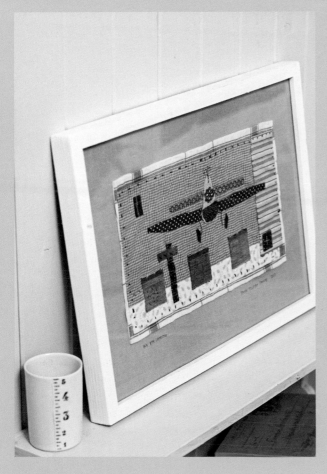

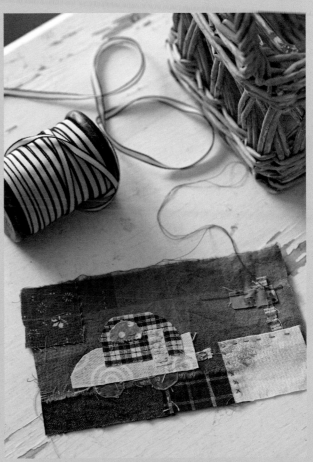

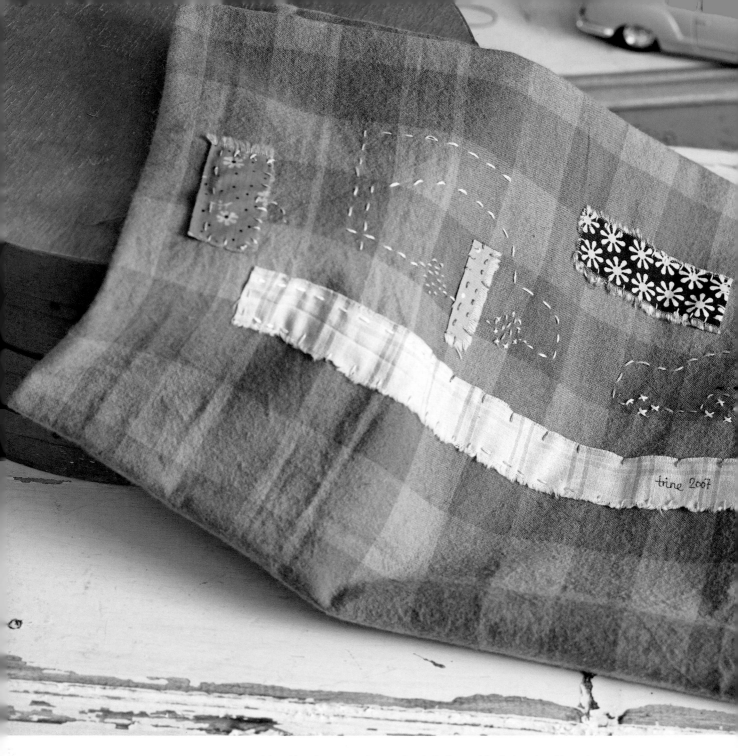

blast. You do not need to appliqué all of the shapes; just find a fabric that reminds you of green soap. It could be patterns in the fabric, designs in the fabric, or simply the structure of the fabric. Choose things from the list that you like the shape of and that fit your apartment. Let the other words stay on the list, or embroider them as text on the picture.

Look at the picture of the plane coming In for a Landing, page 34 The black squares in front are my interpretation of "the little cube things that stand along the runway." I do not know what they're called or what pilots use them for, but when I think of airplanes, these little black blocks come to mind. Maybe I'm really thinking of the blocks the ground crew uses to lock the wheels? Either way, they're in the picture because they're easy to appliqué and beautiful to look at.

There are many ways to appliqué:

1. Invisible hand application , in which you fold the seam allowance with the

can draw on the pattern and iron on the application part) and attach, for example, heavy stitching on the machine or by hand. You can use zigzag here, too.

4. Application with raw edges and rough stitches. The pieces are cut completely freehand right out of the fabric. It's not necessary to think about the seam allowance. However, it's necessary with the world's best fabric scissors, both large and small.

If I want to follow a pattern and draw it exactly, then freezer paper or Vliesofix (2 and 3) are suitable. If it is the impulse method that's used, then enjoy the first and last method the best—especially number 4, I've discovered.

Use the method you master or enjoy the most.

I use tiny little pins about ¾" (1 ½ cm) long to attach the pieces. You can also use spray glue or tacking with machine or by hand.

For the actual application seam allowance, I use all types of thread. I like pearl yarn a lot because it's so thick and shiny. It is necessary to find needles and needle threaders to fit the threads you choose.

Assembly in glass and frame you can get done with a proper frame maker. Or you can do it yourself. Use pretty cardboard and make holes in it with a nail or an awl. Use the holes to attach the picture to the cardboard plate. Customize the cardboard size to the frame you obtain. At IKEA, and also at flea markets, you can find a lot of nice things to assemble in. The cardboard you can buy at a good specialty shop for framing. It's a kind of cardboard substance of mountboard quality. It can well be characterized by tissue structure from bonded fabric.

needle from the upper side while sewing. Done often by freehand. Here, you need to calculate the seam allowance.

2. Invisible hand application with freezer paper. Freezer paper is then marked up with a pattern. It can be on top or under the fabric.

3. Application using Vliesofix (Vlieselin with adhesive on both sides so one

A bubble and no less than two old-fashioned egg caravans in a row. At the end of the procession is a free bird who isn't bound by chains or a cage. It is completely free. This runner was submitted to a competition. The result got bottom placing. I thought I had done well, until I understood that the grading went the other way. Pooh, pooh.

Free Bird on Its Own Wheel I

The runner measures about 33 ¼" x 16 ¾" (83 cm x 42 cm) pre-washed and shrunk

The Anatomy
A long panel of applications is surrounded by two frames. The panel is put together by three rectangles in various sizes. The applications go across the stitched rectangles.

Thoughts about Fabric Choice
This fits romantic, bright, and light fabric with modest contrast. The green frame gives a certain setting.

Cutting Plan
*Rectangles for
the application base*
5 ¼" x 8 ¼" (left) (13 ½ cm x 21 cm).

5 ¼" x 7 ¼" (middle) (13 ½ cm x 18 ½ cm).
5 ¼" x 7 ¾" (right) (13 ½ cm x 20 cm).

Frames
The green frame is cut 1 ½" (4 cm) wide.
The floral frame is cut 4 ¾" (12 cm) wide.

The Seam Work
Sew the rectangles so that you can begin to appliqué. Draw the application pattern on Vliesofix. Draw each part separately and roughly cut it out. Iron against the application fabric's back side. Cut precisely. Peel off the paper. Iron parts on the application's base. Sew around all the pieces with heavy stitching by hand or machine. See "All the Test Subjects in the Basket," page 76.

Materials

- 20 cm of three different fabrics for the application's backgrounds. One is linen.
- 9 different fabrics for the applications. Each piece measures a maximum of 10 cm.
Frames:
- green stripe, 15 cm.
- floral, 45 cm.
Border;
- 20 cm bright red fabric.
Backing and wadding:
- 1 x 0.5 meters.

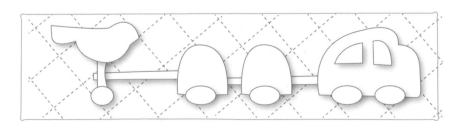

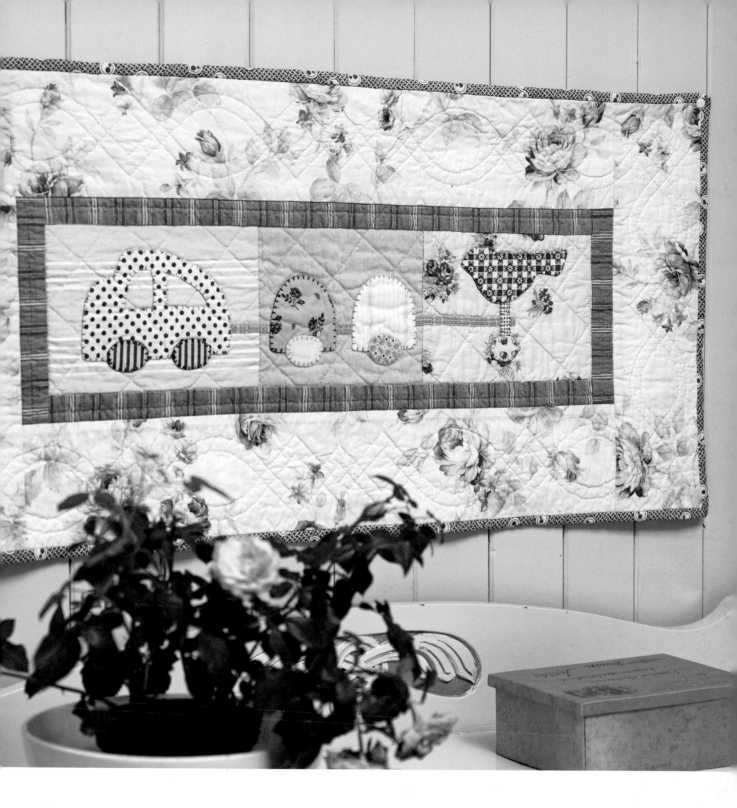

Sew on the long green frames, then short. Use the same sequence for the outer frame.

Quilting

It is quilted outermost in the green border, down in the seam. It his also done outermost around the middle section. The green border has got stitching a seam allowance from the edge. I have quilted around each part of the application.

The application background is cross quilted with lattices that are 2" x 2" (5 cm x 5 cm). No sewing goes across the application parts. I secured each time I encountered a figure. The floral border is quilted using "Borders Made Easy No. 102," see "Ginger Snaps in Jane Austen's Direction," page 68.

Binding

Cut the binding 2 ¼" (5 ½ cm).

While traveling far from home, I missed hand sewing. It had to be improvised. I had only tiny squares left-over from pervious projects that were pre-cut a size of 2" x 2" (5 cm x 5 cm), so, not large. A few slightly larger pieces intended for filler fabric were also included, but I promise, the selection of materials was very limited. The result was a sailboat and a square compass without the directional East.

Just West

Materials

Yes, there is not much! Some pieces, a maximum of 8" x 4" (20 cm x 10 cm), are all you need. Plus, the thread you have in your sewing box at the moment. The most challenging thing is to find a frame afterward that matches the picture. Therefore, it is wise to make the bottom piece larger than you feel it should be so you have some centimeters here and there to adjust the picture opening with.

The picture inside the frame measures about 5 ½" x 3 ½" (14 cm x 9 cm)

The Seam Work

All pieces are cut out using cardboard templates and the rest, by eye. The elements are fastened together with pins, and then sewn together with sloppy tacking. Embroidery of N, S, and V (West) is, however tentatively, done nicely.

Framing

Use the cardboard inside the picture opening, and tighten the embroidery around this. Tape on the back side. Take out the glass in the frame if you think it will be better off without. "Glass" made of plastic is not pretty—it looks off.

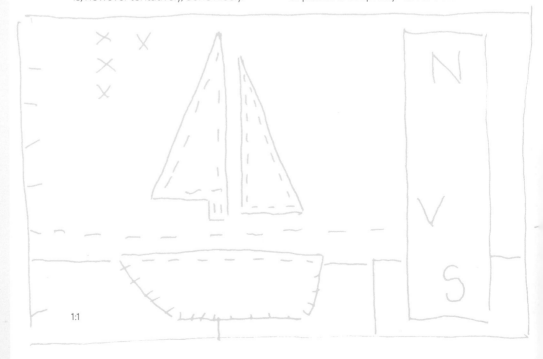

1:1

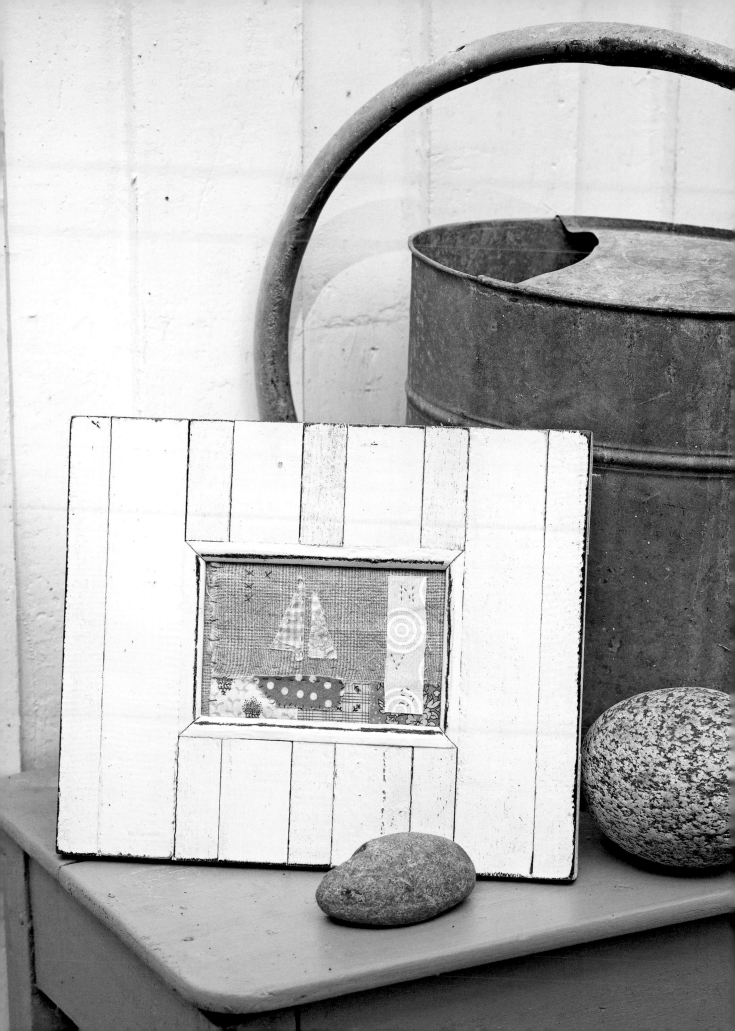

An ad in a magazine gave shape inspiration to the plane. I always look for nice shapes and tear out or sketch anything I see that appeals to me. This aircraft had long been under the cover of "good lines." While I made the background, I was impatient and had to amuse myself a bit with a vibrant fabric on the right side. As the application took shape, I realized it had to happen more on the left side. Therefore, a signpost points to the left. It's also why you'll find a useless square in the upper left corner. It is there just for the sake of the balance—don't imagine anything. (Or maybe it is a balance rudder that's gone awry?) In the bottom left black square, I embroidered my initials.

Materials

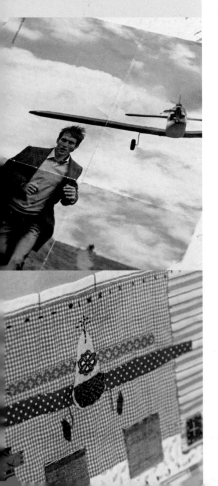

ⓘ Some old tea towels and fabric pieces, a maximum 12" x 8" (30 cm x 20 cm), and a small remnant of a tweed coat on the nose of the plane.

In for a Landing

Application inside the frame measures 13 ¾" x 8" (34 cm x 20 cm)

Thoughts about Fabric Choice

Do you think there were cheers in the house when I found a fabric with a propeller? It is basically a small part of a large flower on a fabric from the '60s,

I think. That's half the fun in messing around in the attic and in remnant boxes.

Assembly

This particular piece I got from Cecilie Dedichen. See the last paragraph before "Just West," page 40.

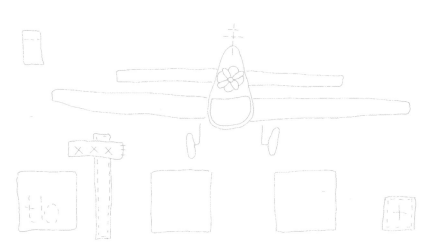

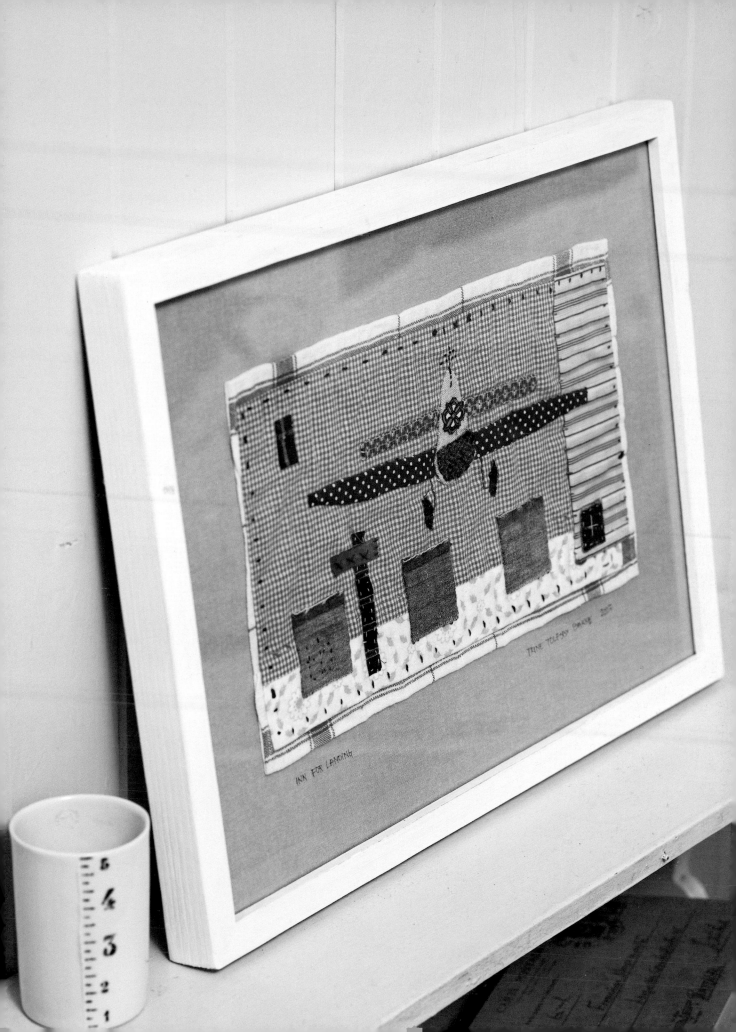

The first vehicle I owned was a bright white VW Beetle. It gave me, just like the moped before it, a whole new sense of freedom. Transport was no longer limited by train times. Had it been possible, the Beetle would have had red-checkered curtains, pink exhaust pipes, and flower boxes in the windows, like a 2CV looked a decade before. In reality, the Beetle was stripped of accessories. In the application, I have recreated the original imagination.

My First Car

This is an attempt at a mosaic. You can see how I have tacked on the different pieces with bright green thread. When the last application stitch has been set, I remove the bright green thread. Note that the pieces that make up the background are roughly patched together.

There are raw edges, and it is sloppily performed. Just my taste. I use a lot of time trying to decide which thread color I'm going to appliqué. Right here, I found that the right side is light, so I appliquéd with dark thread, to some extent, to offset this.

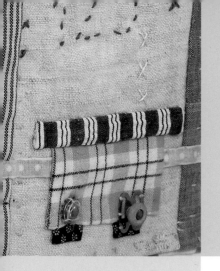

Due to a competition announcement, I have interpreted the term "Free as a bird" using a semi-trailer and long-range transport. It is possible to take a whole house along and go exactly where you want, when you want. The bird is the bandwagon and has its own craft, with its own wheel. If it gets boring, it can lift off the post. Or it can stay. The picture is a preliminary work to the real contribution that is the blanket on page 39.

Materials

- Some broken screws, buttons, and a little fabric substance. See also "Inn for a Landing," page 42

Free Bird on Its Own Wheel II

Application within the frame measures about 12 ¼" x 5 ½" (31 cm x 14 cm)

The Anatomy
The structure is made as previously described, with kitchen towels, fabric pieces, and free associations.

Assembly
See the last paragraph before "Just West," page 40

A final digression
It appears that transport and speed are my thing. Reading through the text, it struck me that all applications had to do with vehicles. When the car goes off on a low gear and revs, then I have fun. Or when the sailboat buckles in a sharp crosswind, and pots and pans down in the cabin tumble to the deck. Really fun. Or the fastest route down the slalom course , when my thighs are screaming and the snow is blowing. Maybe it's just as good that I was never allowed to buy a heavy motorcycle. Well, I have sewing for recreation, which is not something that goes away instantly.

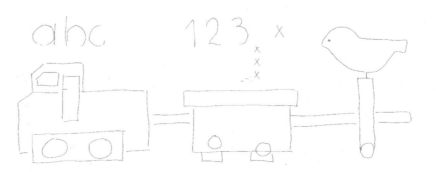

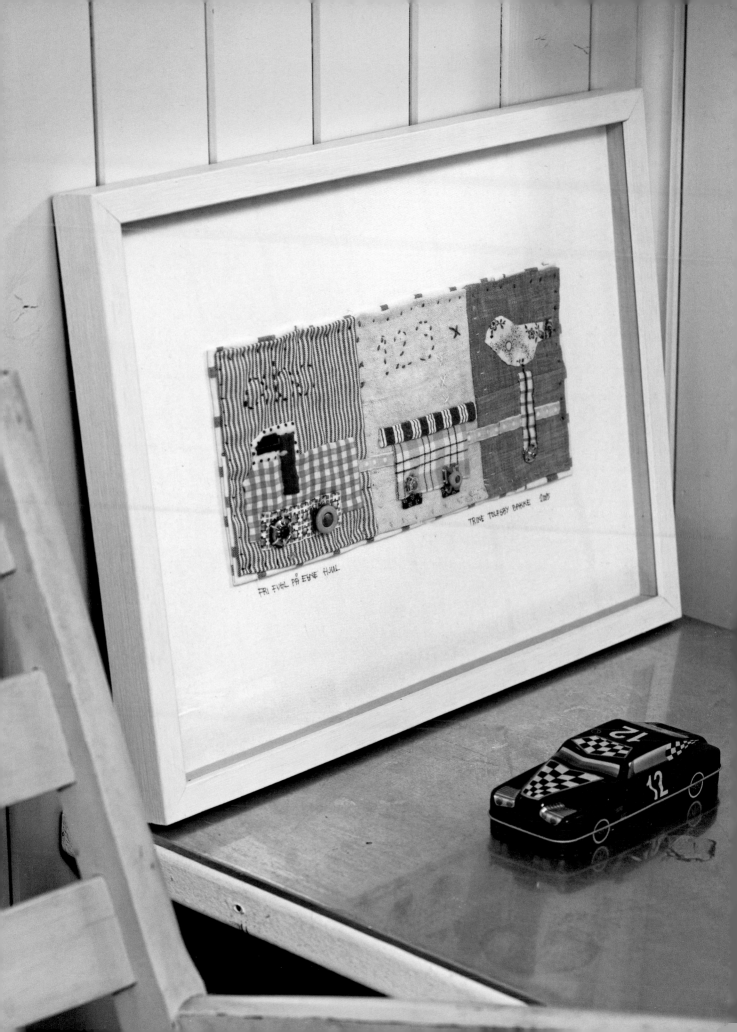

This is a "welcome" sign. This can hang outside the house if the wall is protected from wind, sun, and rain. Or it can be hung in the hall. I have appliquéed "Bakke" and "est. 1988" in such a way that it will appear at second glance. You could choose a clearer contrast between the background and letters to make it look more like a real door sign.

Door Quilt with Seasonal Variation

Door banner measures about 14 ¾" x 22 ½" (37 x 56 cm) pre-washed and shrunk

The year is selected on the basis of our wedding year. Other alternatives can be when you met each other, when the house was built, when you moved from home, or when the first child came. Regardless, it is a tribute to the family, home, and the relationship.

The hearts symbolize the mother, father, and all of the kids. The last is combined in one heart. This does not decide , therefore, how many children are to be produced. Make your own number of hearts and tell each and every one in the family who represents what. Great fun. Remember dogs and cats, if you have any. Is space lacking based on compositional considerations? Spread the hearts over the frame. If so, select an almost equal color for the heart as for the frame so the heart doesn't interfere with the frame. Or quilt the hearts. Do you have a deceased person you want to include? Quilt a star in the sky above the house. Or sew on a star button.

The blanket is joined by six different pendants that button on and off depending on the season or festival at hand. This is a great gift for weddings and surrounding days. Pendants can be sewn

little by little and be gifts for a long time to come.

The Anatomy

The pendants are different in size. Be precise when placing the loops so they fit the buttons on the door banner. If you give the blanket as a gift, you must note the distance between the buttons so that the loops are in the right place when sewing any additional pendants as a gift later.

Thoughts about Fabric Choice

The pendant and door banner work color-wise separately and together. This requires that you modulate many colors to each other. As I sewed, I found that it would be easier if the door banner initially had a few more colors. There was little to play on when varying the colors for the pendants.

Cutting Plan

Application background for the house in light-striped fabric: 9 ½" x 11 ½" (about 23 ¾ cm x 28 ¾ cm).

Application background for name and date in straw-yellow fabric: 9 ½" x 6 ½" (24 cm x 16.5 cm).
The chessboard, beige-checkered fabric: About 2" x 30" (it will hold to 14 bits on 2" x 2" (5 cm x 5 cm).

Materials

- Application's background for the house in a bright striped fabric: 10" (25 cm).
- Application's background for the name and date in straw-yellow fabric: 8" (20 cm).
- House fabric in dark red-checkered fabric: 4" (10 cm).
- 3 different red-checkered fabrics for hearts: 2 7/8" x 1 ¾" (7 cm x 4 cm).
- Beige checkered fabric for the letters and year: 2" (5 cm).
- The chessboard squares, beige checkered fabric: 4" (10 cm).
- The chessboard squares, blue dotted fabric: 4" (10 cm).

Frames in blue:
- 8" (20 cm)

Border in dark red checkered fabric
- 6" (15 cm)

Suspension sleeve behind preferably in the same fabric as back panel
- 6" (15 cm)

Backing and Batting:
- 24" x 32" (60 x 80 cm)
- 2 buttons

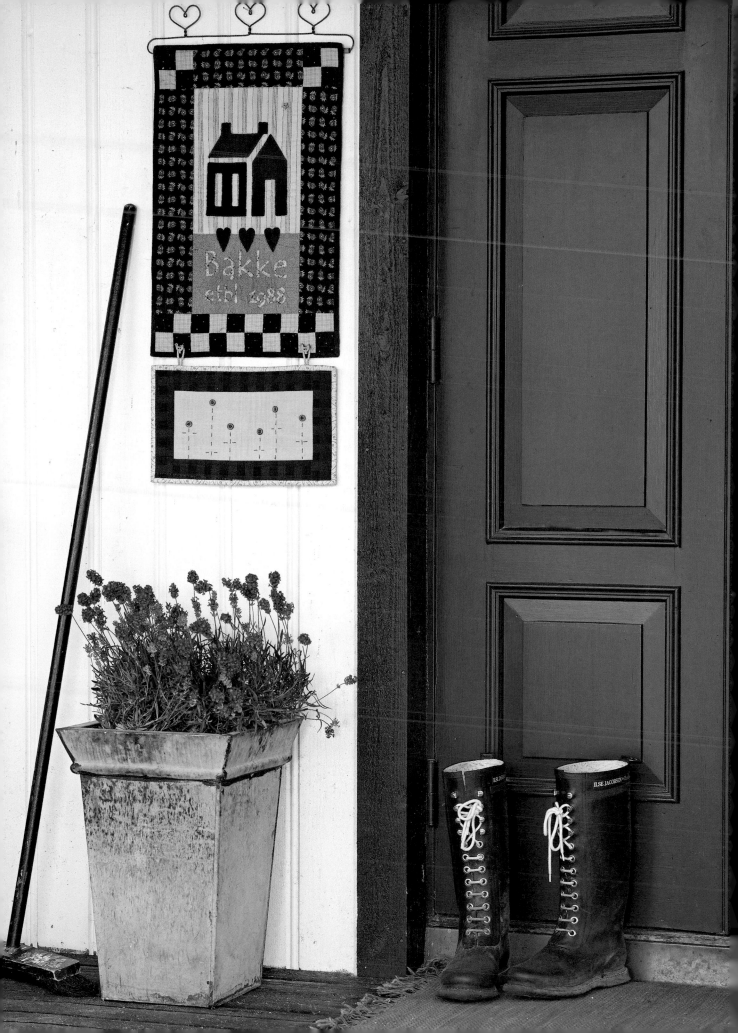

ABCDEFGHIJKL
MNOPQRSTUV
W XZ

Abcdefghijklm-
nopqrstuvwxyz

1234567890

The chessboard, dotted blue fabric:
2" x about 30" (5 cm x 75 cm) (it should keep to 14 pieces 2" x 2") (5 cm x 5 cm).
Frames in blue fabric:
2 pieces 3 ½" x 17 ½" (about 8 ¾ cm x 43 ¾ cm) and 1 piece 3 ½" x 9 ½" (about 8 ¾ cm x 23 ¾ cm).
Border in dark red-checkered fabric:
2 ¼" x 90" (about 6 cm x 225 cm) (about 9 cm).
Hanging sleeve:
14" x 4" (35 cm x 10 cm).

The Seam Work for the House

Draw the house on Vliesofix and cut roughly out (see pattern sheet). Iron against the house fabric's back side. Cut out by the line. Peel off the paper, and iron in place on the striped background fabric. Appliqué the motif firmly. I used heavy stitching on the machine and Lene's silk thread.

Appliqué names and dates: Out with the computer and a word processor. Or ask someone to help you. Write your own last name in many different fonts. Browse the letters you think are great. I used Tempus Sans ITC on "Bakke," and "est. 1988" is written in Lucida black letter. Then adjust the size of the letters so they fit in the space available to appliqué on. You can make some printouts to find the right size. When you select font, you should think that the bolder the font is, the easier it is to appliqué. Print the text in the correct size. And MIRROR it. I use a window and a day with bright sunlight. Line up the outlines of each letter with a thick marker. Tape the sheet on the window with the back side toward you. Now the text is reversed. Tape another sheet over it. The contours shine through. Align your own original based on the contours. Then, appliqué the letters using Vliesofix on the name background. I used a cross-stitch program on the sewing machine for "Bakke." The rest were appliquéd with reinforced three-stage straight seam. When washing, the letters floss slightly in the edge, but they sit securely.

If the characters are thin and difficult to appliqué, you can embroider or quilt with contrasting thread. Then you don't mirror. Use the window pane/sunlight method and tape the fabric over the original. Dot the pattern on

the fabric with a sharp pencil. Sew the house part to the name part. Now you can appliqué the hearts in place.

Chess Board: Sew a blue and a beige strip lengthwise. See drawing. Press the seam allowance against the dark fabric. Cut the strip in segments of 2" (5 cm). Turn over every other one and sew it back together. Insert the needle so that the pieces just meet each other in the color transitions. You sew a long chessboard with 2 x 10 pieces and two corners each of 2 x 2 pieces each.

Now ensure that the six middle chess pieces will fall into place exactly under the name part. Remember to account for the seam allowance that will come in connection with the sewing of the blue frames. Sew the two longest blue frames to each long side of the house part as well as the name part. Press seam allowance to the frame. Sew a chessboard corner to each end of the short blue frame. Press the seam allowance toward the frame. Sew the top and the bottom frame in place. Put in needles so that the chessboard fits into the corners.

Quilting

It is quilted in all the seams and around each appliquéd part. The frame has parallel stitching in a ridge pattern.

Border and Hanging Sleeve

Cut the border 2 ¼" (6 cm). Sew the border on, but do not fold it back for hand sewing yet. First, you will sew a hanging sleeve. Lace into short sides of the pendant piece. Press the double lengthwise with right side out. Sew it in place on top, with the seam for the border with raw edge against raw edge. Now sew the border firmly by hand on the back panel. Then sew a hanging sleeve with small invisible stitching. Make a small bulge of about 1/8" (3 mm) so that the list will fit without pushing the blanket out front. Use cleverness and the corner of your eye to secure the pendant to the wall. See sketch.

Finish by sewing two buttons on the pendant. Mine is about 2 ½" (6 cm) in from the edge. There's about 9 ½" (about 24 cm) between them.

Hanging sleeve

Use wall mount, corner of eye, and cleverness.

A perfect opportunity to display buttons that are collected through a long life of sewing. I used five similar buttons, but the result can be great with different buttons, too—different either in size or color. Stems and leaves are embroidered with reinforced straight stitch on the machine. You can benefit just as well by using hand sewing. Choose a thread that gives good contrast to the background.

Back

Back

Button Parade

Materials

- Light green plaid base: 6" (15 cm).
- Frame, checkered black and burgundy: 6" (15 cm).
- Border, floral light fabric: 6" (15 cm).
- Back panel and batting: about 10 ¾" x 17 ½" (27 x 44 cm).
- 5 buttons.
- Dark green embroidery thread.
- Anorak cord: about 8" (20 cm).

Springy and budding pendant for the door banner or a small piece with dimensions of about 14 ½" x 8 ½" (36 cm x 21 ½ cm)

Cutting Plan
Light green base:
11 ½" x 5 ½" (29 cm x 14 cm).
Frame:
2 pieces, 2" x 11 ½" (about 5 cm x 28 ¾ cm), 2 pieces 2" x 9" (about 5 cm x 2 ½ cm).
Border:
2 ¼" (6 cm).

Add buttons throughout, and find a balance. Dot with a pencil line so you see where the stem and leaves should be sewn.

The Seam Work and Quilting
Sew on the frames, and put batting under the entire front piece. If you are sewing by hand, tack the batting and embroider now. Then attach the back panel to the front and batting.

If you choose the machine, it's done in this order: Add the back piece together with the front and the batting. Glue with spray between the layers. Sew with reinforced straight stitching through all three layers. Quilt a little. I've quilted around the bright middle piece and along the squares in the frame. Sew on the buttons.

Border and Hanging Loops
Sew on the border from the right, but do not sew it by hand on the back panel yet. First you sew the anorak strings. These loops will be used to attach the pendants to the bottom of the door banner. Place the cords so they match the buttons you've sewn on the door banner. My measure is about 9 ½" (23 ¾ cm) between the loops. Sew the strings securely to the border seam with the machine. Then fold the border back, and sew by hand. The strings are folded over and fastened with tiny invisible stitching to the border's back panel. See the sketch.

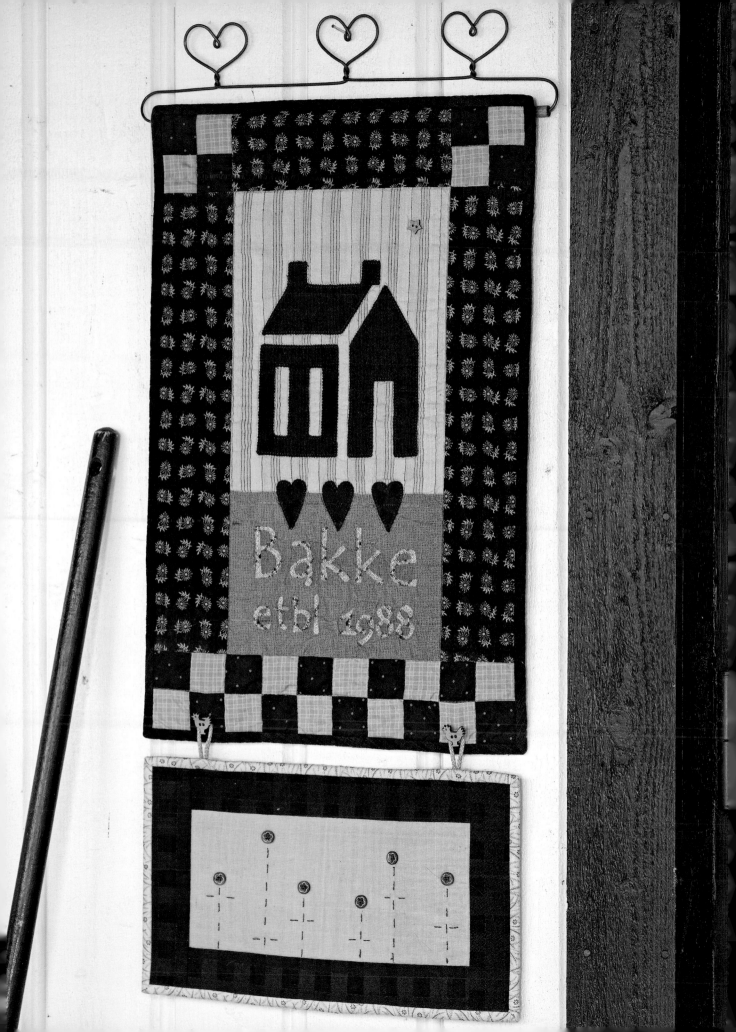

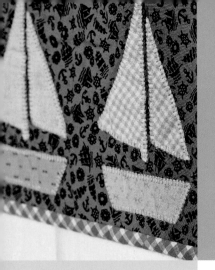

Materials

- Dark, maritime base fabric: about 8" (20 cm).
- Bright, checkered fabric for chessboard: 2" (5 cm).
- Blue, patterned fabric for chessboard: 2" (5 cm).
- Pieces for 2 boat hulls and 2 sets of sails: 4" (10 cm) of each.

Border, blue-checkered:
- 6" (15 cm), more if it is to be cut at an angle.

Back panel and batting:
- 10" x 18" (25 x 45 cm).

Anorak strings in linen:
- 2 pieces of 4" (10 cm).

Tip

Sew the chessboard before you cut the base fabric. Then cut the base fabric in the height the chessboard ends up measuring, after you have sewn it.

Hop On Board

Jolle banner measures about 7 ¼" x 14 ¾" (18 x 37 cm) pre-washed and shrunk

Cutting Plan

Dark maritime fabric:
7 ½" x 11 ½" (19 cm x 29 cm).
A strip of bright plaid fabric for the chessboard:
1 ½" x 24" (3.8 cm x about 60 cm).
A strip of blue patterned fabric for the chessboard:
1 ½" x about 24" (3.8 cm x about 60 cm).
Blue-checkered border:
2 ¼" (about 6 cm) wide.

The Seam Work

Appliqué the sailboats on the dark background fabric. See description of the application under "Door Banner," page 48.
Make a set of stripes of two fabrics for the chessboard. Cut into segments of 1

½" (3 ¾ cm) and sew together two edges comprising 2 x 7 pieces each.

Quilting

Assemble the backing, batting, and top. Quilt in all the seams and around the boats.

Border and Loops

These are sewn as described under "Button Parade," page 52.

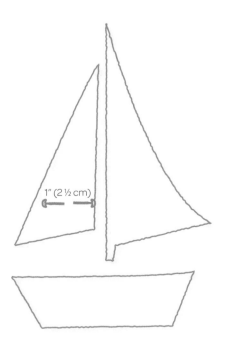

1" (2 ½ cm)

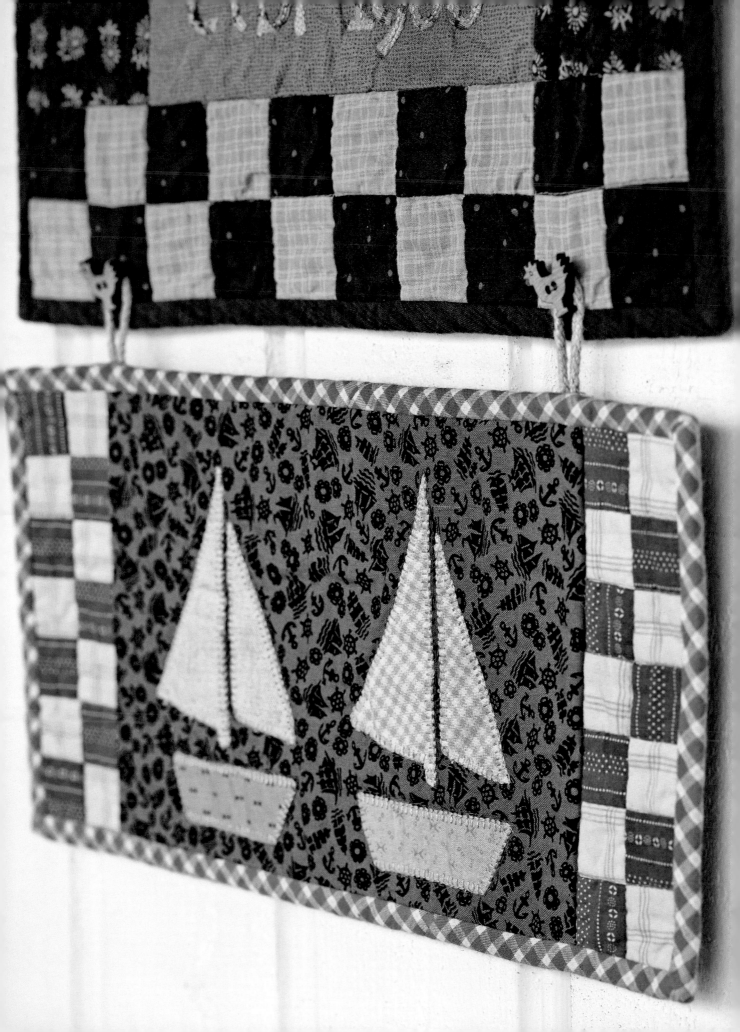

Red apples symbolize the fall harvest. The pendant can be buttoned up late summer and decorate the nameplate until the snow comes. The apples are also great for Christmas.

Fall Pendant for Door Quilt

Materials

- Light brown base: 6" (15 cm).
- 3 red apples: each piece 4" x 4" (10 x 10 cm).
- Stems: a little brown fabric.
- Leaves: a little green fabric.
- Mouliné yarn remnants for hull.
- Frame: 6" (15 cm).

Border:
- 6" (15 cm) (more if you cut it at an angle).

Back panel and batting:
- about 10 ¾" x 17 ½" (27 cm x 44 cm).
- ½" x 6 ½" (2 cm x 16 cm) bands plus two buttons for hanging.

2 ½" (6 cm)

The apple picture has a size of about 14 ¾" x 8 ¾" (37 x 22 cm) pre-washed and shrunk

Cutting Plan
Base:
11 ½" x 5 ½" (29 cm x 14 cm).
Frame: 2 pieces
2" x 11 ½" (about 5 cm x 28 ¾ cm) and 2 pieces 2" x 9" (about 5 cm x 23 cm).

The Seam Work
Sew the frame on the brown middle piece. Appliqué the apples, see description under "Door Banner," page 48. I actually appliquéd the apples after I put the batting and backing behind the tile. This makes it application and quilting at the same time. This method is suitable only when machine-sewing. Add a tassel of mouliné yarn underneath the apple when you appliqué. It's the hull.

Quilting
It is quilted in all seams. For hand sewing, you quilt around the apples, too. Also do a Borders Made Easy table on the frame. It has number 105

Border and Hanging Loops
The border is sewn on pre-made. Then fold and sew on a band for the hull. The seam is covered with a button.

½" (2 cm)

Quilting sketch 1:1

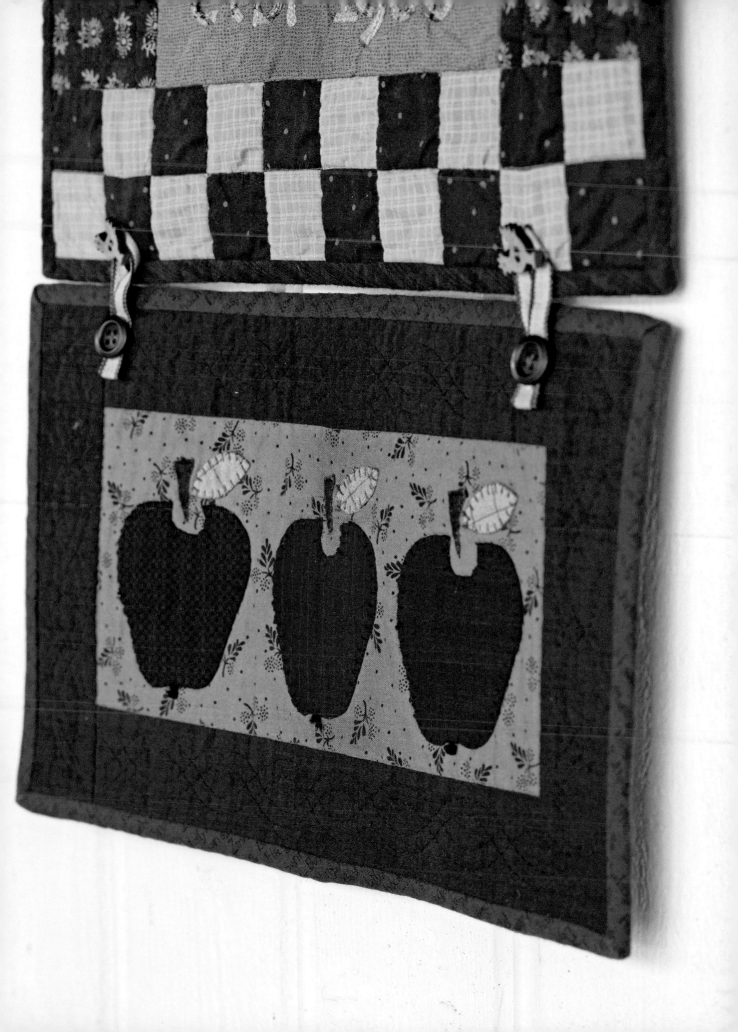

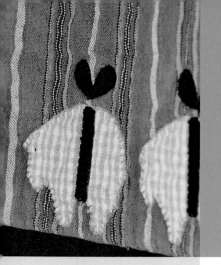

Materials

- Striped middle piece:
 6" (15 cm).
- Pieces for pigs: 4"
 (10 cm).
- Pieces for packaging
 straps: 4" (10 cm).
- Dark reddish-purple
 frame and border:
 6" (15 cm).
Back panel and backing:
- 10" (25 cm).
- ½" x 6 ¼" (2 cm x 16 cm)
 bands plus two buttons
 for hanging.

On the Way to the Christmas Table

Slakte cover in a size of about 7 ¼" x 13 ¼" (18 cm x 33 cm) pre-washed and shrunk

This pendant promises polka pigs, Christmas dinner, pork ribs, marzipan pigs, and Christmas gifts—all in one application and association.

Cutting Plan

Striped middle piece:
10 ¼" x 4 ½" (26 cm x 11 ½ cm).
Frame:
2" (5 cm) wide, 2 pieces 10 ¼" (26 cm) long and 2 pieces 7 ½" long.
Border:
2 ¼" (6 cm) wide.

The Seam Work

Appliqué the pigs on the background fabric. See if necessary a more detailed description under "Fall Pendant" and "House Blanket," pages 48 and 56. Sew on the frame. The tails and the eyes are drawn on with fabric markers, but they can also be embroidered.

Quilting

Assemble the back panel, batting, and top. Quilt in all the seams and around the pigs. The frame is quilted like "Fall Pendant," page 56.

Border and Hanging Loops

The border is sewn on complete. Then you fold and sew on a band for the loops. The seam is covered with a button.

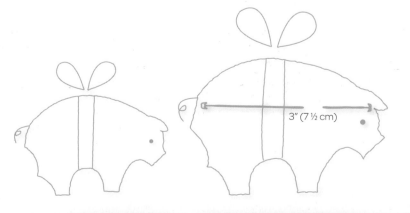

3" (7 ½ cm)

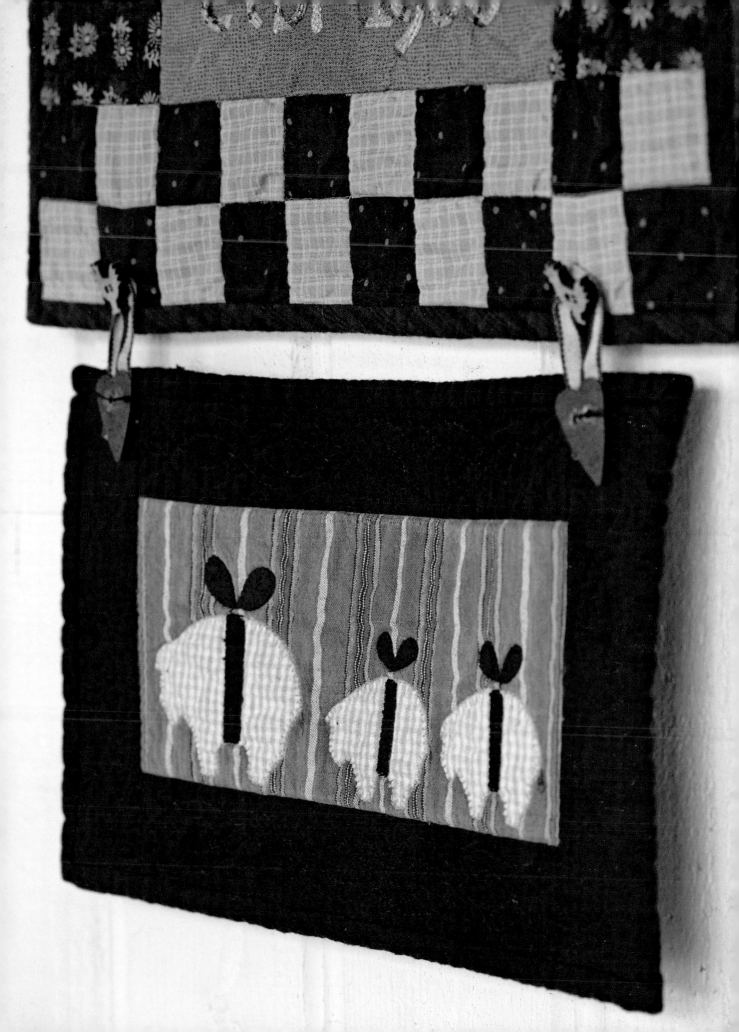

Miraculously, I have been responsible for three children having dry and warm mittens on them for every cold season. As children grow, they learn to accept that the mittens come from different pairs. It has been the salvation for me many times—just to be able to give them, for example, one knitted right-hand mitten in a woolen pattern, while the left-hand mitten is a solid-color blue, bought at Hennes & Mauritz. In this little picture, the mittens are a pair, they look better that way.

Mom, Where Are My Mittens?

Materials

- Bright patterned application base: 8" (20 cm).
- Blue-checkered fabric for mittens: 6"x 8" (15 cm x 20 cm).
- Mustard-colored fabric for the cuffs and chessboard on the sides: 4" (10 cm).
- Striped light-blue fabric for the chessboard on the sides: 4" (10 cm).
Binding:
- 6" (15 cm) (more if it will be bias cut).
Back Panel and Batting:
- about. 8" x 16" (20 cm x 40 cm).
- 2 bands about 6 ½" (16 ¼ cm), plus 2 buttons for hanging up.

Exploration blanket in a size of about 6 ½" x 14/ ½" (16 ½ cm x 36 ½ cm) pre-washed and shrunk

Cutting Plan
Light base:
10 ¾" x 6 ½" (27 cm x 16 ½ cm)
Checker border:
1 ½" x 1 ½" (3.8 cm x 3.8 cm), 12 blue and 12 mustard
Binding:
2 ¼" (5 ½ cm) wide

The Seam Work
Sew two sets of side chessboards of 6 x 2 pieces.

Sew one side chessboard piece to each side of the base piece. Appliqué the mittens on the base. See "Fall Pendant" for the procedure, page 56.

Quilting
Assemble the back panel, batting, and top. Quilt in all of the seams and around the mittens. The mustard-colored pieces are cross quilted.

Binding and Hanging Loops
The binding is sewn on entirely completed. Then, you fold and sew on a band for the loops. The seam is covered with a button.

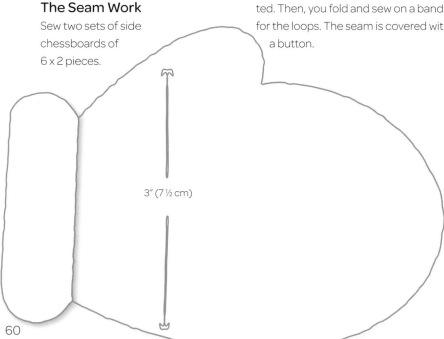

3" (7 ½ cm)

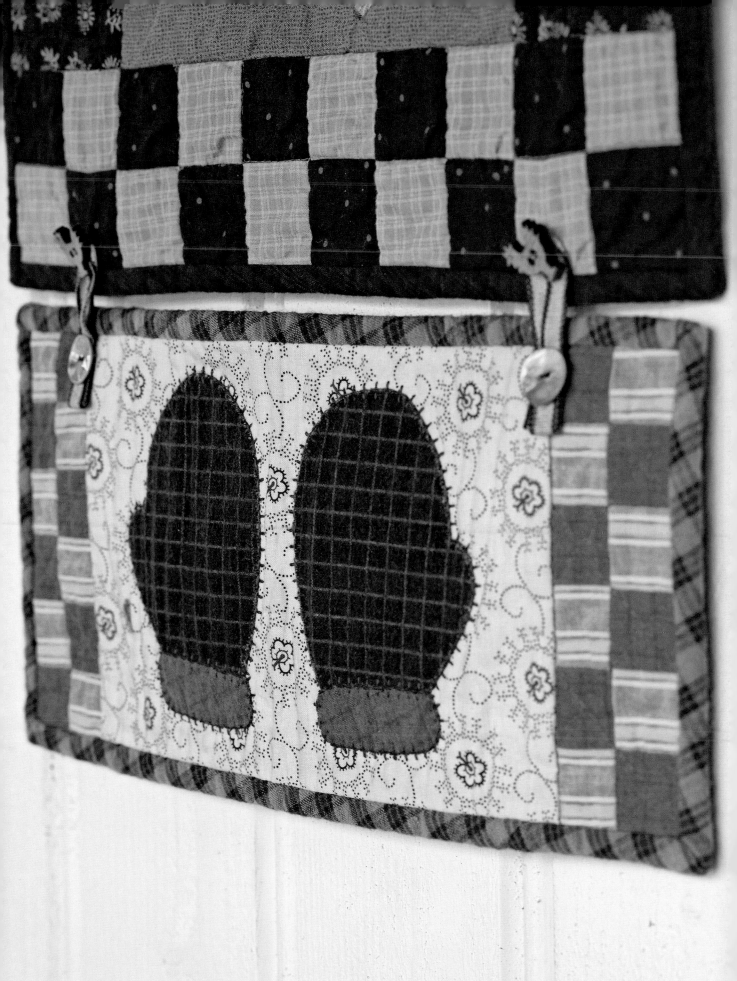

With old decorative towels as inspiration, I've drawn an Easter chick and written an Easter greeting. The linen fabric and the frame were put together with batting and backing BEFORE I embroidered. In this way, embroidery also becomes a kind of quilting.

Easter Chick That Can Read

Materials

- Linen: about 16" (40 cm) (should be washed before use due to shrinkage)
- Blue fabric for edge and border: 8" (20 cm).
- Back panel and batting: about 12" (30 cm).
- Anorak string: about 8" (20 cm).
- Embroidery thread for machine or hand sewing

Embroidered picture a size of about 8 ½" x 14 ¼" (21 ½ cm x 35 ½ cm)

Cutting Plan

Linen:
11 ½" x 5 ½" (29 cm x 14 cm).
Blue border:
2" x 11 ½," 2 pieces and 2" x 8 ½," 2 pieces.
Border:
2 ¼" (5 cm) wide.

The Seam Work

Cut linen and sew on the frame. Draw the embroidery pattern on the linen fabric. Use daylight, window, and tape to transmit as follows: Draw all of the linen embroidery lines on a thin piece of mat paper with a thick, black marker. Let it dry completely. Tape the mat paper up on the window. Tape linen and frame over this. Dot a careful pencil line on the linen so you can embroider by it.

Machine Embroidery With Normal Sewing Machine

Add layers of backing and batting with linen/frame on the very top. Sew by the pencil line with embroidery stitching and silk thread. You have to lift the foot and turn frequently. Use the needle stop down for easy turning while the line is not broken. With the machine, it's easy to get through all three layers, but a drawback is that the back panel can get

matted with thread. I "hide" the thread in a backing that is a busy pattern and the right color of the thread. Of course, the back should also match the front. It can be embroidered by hand with Mouliné yarn or by machine with embroidery thread. I used Lene's silk thread and a sewing machine.

Stitching on the machine:

Saddle stitch, No. 73
on the Janome MC 10000
Cross stitch, No. 201 on Janome
3-step stretch, No. 5 still on
Janome MC 10000

Most sewing machine computers have reinforced straight seam. It is suitable for embroidery. You use the machine just as for normal sewing, that is, no "freehand stuff." I like it better, because then I have control over stitch length, thread tension, and, not least, the subject. The result is just as detailed as what I would have drawn. I allow myself to deviate a little from the drawing while I sew, but it's mostly because "it happened when I didn't mean it." This way, to embroider demands that the work doesn't get too great, because you always have to

twist and turn for the stitches to fall in the right place. Always stop with the

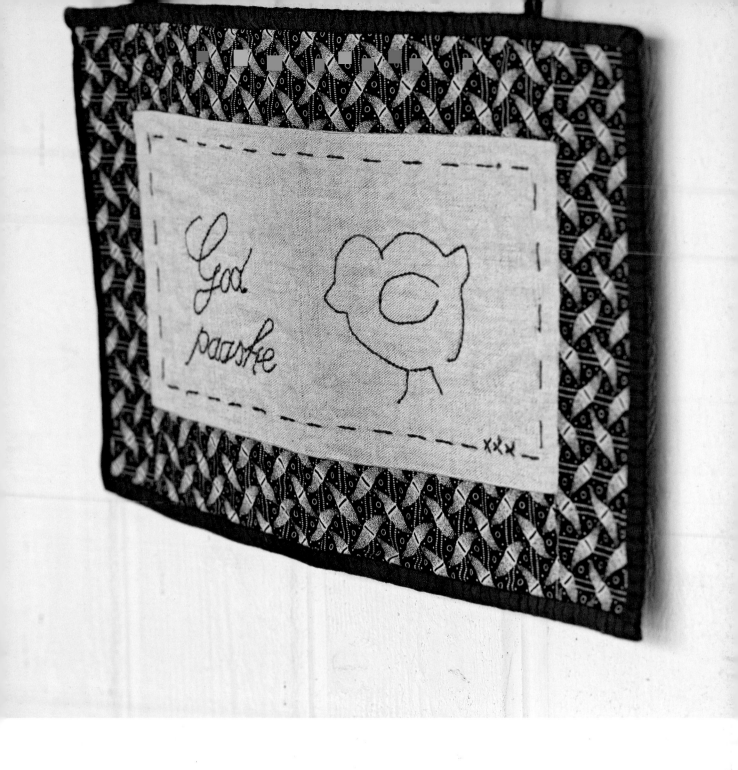

needle down. And learn the stitch in such a way that you always know if the machine takes a step forward or one back.

Use the application foot. Then it is easier to see which way to turn to follow the pencil line. If you have a Pfaff machine with a conveyor, you should use it. Choose application foot, which is open in back so you can plug into the conveyor.

On Janome, I facilitate foot pressure. Experiment on your own machine, as there are many undiscovered seams and waiting for you in the instruction book. Or—simply—sew by hand. Stitchery is good.

If you sew embroidery stitch by hand, you discover that it is heavy and unnecessary to go through three layers. I would recommend hand sewers to embroider only in linen and assemble

the usual "patchwork/quilt way" afterward. Or, if necessary, use the stitchery method and add the batting behind the linen before you embroider.

Quilting
Sew a seam around the stitching in the linen.

Border and Hanging Loops
See "Button Parade," page 52.

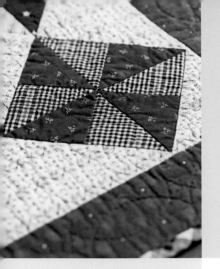

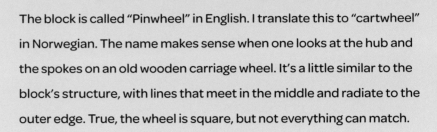

11/8"

The block is called "Pinwheel" in English. I translate this to "cartwheel" in Norwegian. The name makes sense when one looks at the hub and the spokes on an old wooden carriage wheel. It's a little similar to the block's structure, with lines that meet in the middle and radiate to the outer edge. True, the wheel is square, but not everything can match.

Materials

For six blocks:
- 12" (30 cm) different blue remnants, at least 6" x 8" (15 cm x 20 cm) for each block.
- 12" (30 cm) various lighter remnants, at least 6" x 8" (15 cm x 20 cm) for each block.

Filler fabric:
- 20" (50 cm) striped light repro fabric.

Frames:
- 20" (50 cm) medium blue fabric.

Border:
- 16" (40 cm) gray plaid fabric cut at an angle (if you're not inclined to cut at an angle, keep it to 6"/15 cm).

Backing and batting:
- 28" x 36" (70 cm x 90 cm).

Kitchen Tablecloth

Runner measures about 20 ¾" x 28" (52 cm x 70 cm) pre-washed and shrunk.

Size of pre-sewn cart wheel block 5 ½" (about 14 cm)

Thoughts about Fabric Choice

Wagon wheel blocks are kept in blue plus a color. The second color should be brighter than the blue, and it should be varied. I've used olive, red, black-checkered-red, and beige remnants. The filler fabric is almost equal to the lightest piece of the cartwheel, just a little lighter.

Cutting Plan and Seam Description

Blocks:
Cut out two dark and two light squares 4" x 4" (10 cm x 10 cm).

Add a dark and a light on top of each other, right sides together. Iron them "together." Draw a diagonal line with a ruler and pencil.

Sew along the ruler mark on each side a sewing machine foot's width of seam allowance. Cut along the ruler mark. Open up and iron against the dark fabric.

Use a square ruler with a 45-degree diagonal line and trim angled squares to 3

¼" x 3 ¼" (8 cm x 8 cm) wide. Be sure to keep the tips in the corners, since they must not be dislodged. Sew the four angled squares into a cartwheel block. You will sew six such blocks.

Filler Fabric

2 blocks are cut 6" x 6" (15 cm x 15 cm). They are put in the middle of the tablecloth.

For the side triangles, you cut 2 pieces 9 ½" x 9 ½" (24 cm x 24 cm) that you split diagonally 2 times. This makes 8 triangles (2 left over).

For the corner triangles, you use 2 pieces 5" x 5" (13 cm x 13 cm) you divide diagonally 1 time.

All the triangles are too large and must be cut down when you are finished sewing the tablecloth together. Be sure to keep enough seam allowance to sew on the frame without cutting away cart wheel tips.

Frames

The frame is cut 3 ½" (about 9 cm) wide.

The Seam Work

The runner is sewn together at an angle into strips with a cartwheel and filler

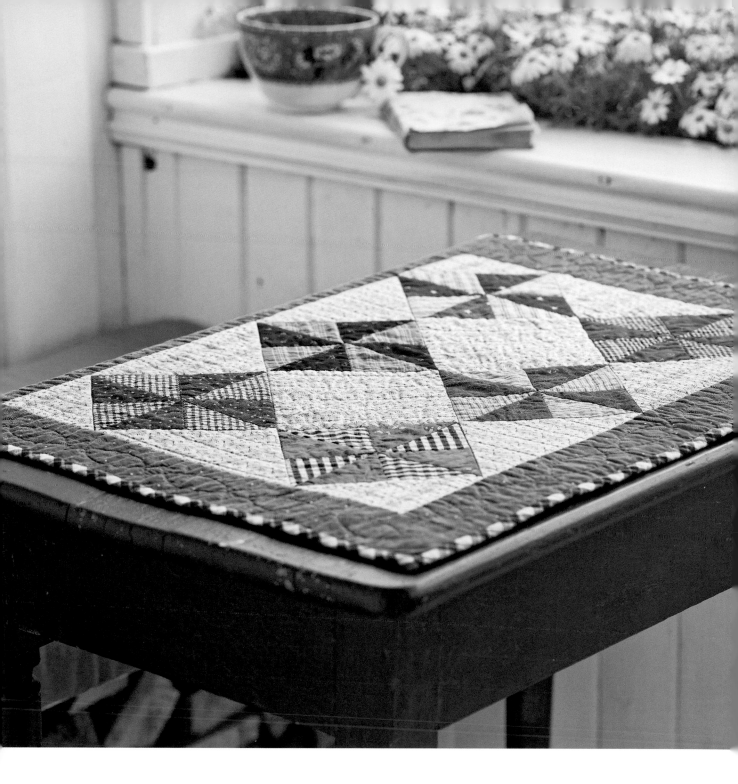

fabric every other time. See the
sketch.

Quilting

Quilting follows the stripes in the
entire blocks, and one stitching is
sewn for most of the grooves. The
frame has a Borders Made Easy
quilting with No. 104

Border

Cut to measure 2 ¼" (5 ½ cm).

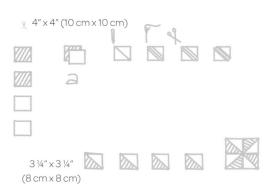

4" x 4" (10 cm x 10 cm)

3 ¼" x 3 ¼"
(8 cm x 8 cm)

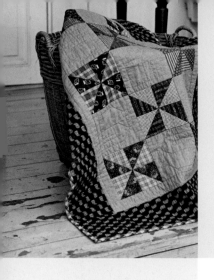

There were too many blocks sewn for the kitchen tablecloth. The remnants are repurposed in this small blanket that is just right for a crib.

Crib Blanket

Materials

For 8 blocks:
- 12" (30 cm) different blue remnants, at least 6" x 8" (15 cm x 20 cm) for each block.
- 12" (30 cm) different lighter remnants, at least 6" x 8" (15 cm x 20 cm) for each block.

Filler fabric:
- 28" (70 cm) light, thin, jeans-colored fabric.

Frames:
- about 32" (80 cm) medium-blue fabric if you don't want to cut the edge (keep to 24"/60 cm if you cut).

Border:
- 16" (40 cm) bright red plaid fabric cut at an angle (if you do not cut at an angle, keep it to 6"/15 cm).

Backing and batting:
- (1 m x 1.3 m).

About 28 ¼" x 40" (71 cm x 100 cm) pre-washed and shrunk.
Size of pre-sewn cartwheel block 5 ½" (about 14 cm)

Thoughts about Fabric Choice

I've selected the most vibrant and colorful cartwheel blocks to the extent that these blocks can be called that. The kitchen tablecloth blocks are a bit more conservative. The filler fabric is markedly denim-like, but of thin quality. If you have men's shirts in cotton lying around, they will certainly be suitable. The border brings out the red elements inside the blanket.

Cutting Plan

Blocks:
See description of "Kitchen Tablecloth," page 64. You will sew 8 blocks.
Filler fabric:
Cut 7 blocks of jeans fabric 6" x 6" (15.2 cm x 15.2 cm).
The innermost frame of denim fabric:
2 pieces 2" x 20" (5 cm x 50 cm).
2 pieces 2" x 28" (5 cm x 70 cm).
Frame in navy blue fabric:
2 pieces 5 ¼" x 29 ½" (13 ½ cm x 74 cm).
2 pieces 5 ¼" x 31" (13 ½ cm x 77 ½ cm).

Quilting

Silhouettes of houses were quilted for all of the denim fabric blocks. There is one stitching for the bright denim fabric a machine foot's width from the seam allowance, and otherwise all groove seams are quilted. The back panel is flannel. The border is decorated with Borders Made Easy no. 102 (the same as used on "Ginger Snaps in Jane Austen's Direction," page 68).

Border

Cut to measure 2 ¼" (5 ½ cm).

2" (5 cm)

Quilting sketch

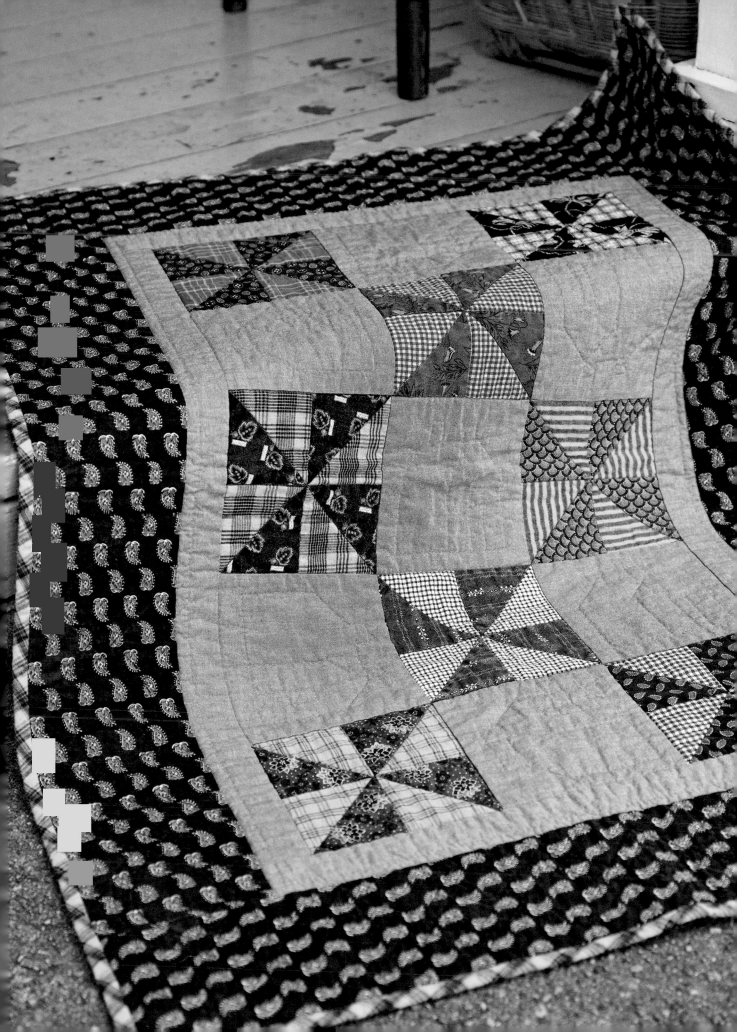

Jane Austen, her sister, Cassandra, and her mother made a quilt around 1810 that is now located in the museum in Chawton, Hampshire, England. It is entirely made by hand. It is not quilted, but is assembled as a kind of down blanket. Here is my copy.

Materials

- For 265 ginger snaps, you need about 90 different pieces of about 10" x 12 " (25 cm x 30 cm) I have up to 3 identical pieces of each fabric in the blanket. 265 ginger snaps divided by 90 different fabrics is equal to about 3 pieces of each fabric.

Sashing:
- about 118" (3 m).

Frame:
- about 43 ¼" (1.1 m) light brownish gray fabric if you're joining (71"/1.8 m to avoid it).

Border:
- about 20" (50 cm) blue fabric.

Backing and batting:
- 79" x 94 ½" (2 m x 2.4 m).

Ginger Snaps in Jane Austen's Direction

Bedspread measures about 54 ¾" x 84" (138 cm x 210 cm)
pre-washed and shrunk
Size pre-sewn ginger snap
One side measures about 2 ¾" (7 cm)

In the original blanket, the design is built around a large central field shaped like a ginger snap with smaller ginger snaps surrounding it. They are placed symmetrically with latticework in between. The frame consists of dense, smaller ginger snaps. The old blanket has given me inspiration to sew my own variation. In my local quilting circle, many have taken a course with me and my former students, and have made their own Jane Austen clones. I have chosen to just sew the area with medium-size ginger snaps and lattice work. The patches are placed randomly, however, so that the blanket will have a harmonic character. To the extent that it has been possible to obtain fabric reproductions from two centuries ago, these are used. The original blanket is reproduced in the book Lær deg lappeteknikk [Learn Patchwork]

by Lynette-Merlin Syme, published by Ernst G. Mortensen Publishing in 1987. Margaret Sampson has made an interpretation of the blanket in Australian Patchwork & Quilting in 1997. And my version is presented here. It is built with the use of cutting equipment and a sewing machine.

The Anatomy

The blanket has 265 ginger snaps, 23 remnants of everything from one to 23 ginger snaps, 22 long, narrow, and whole strips with lattice work, and 284 oblong, small pieces with lattice work. All of the pieces are not used throughout; some of them are cut off when you trim the blanket to put on the frames.

Thoughts about Fabric Choice

The sashing fabric is in a light, romantic pattern. Moderate contrast in the pattern is best. There shouldn't at all be a foreseeable pattern because then the sight is skewed in the seams. It is easiest to choose the sashing after you have cut the ginger snaps. Add an excess of about 20 ginger snaps in your sashing,

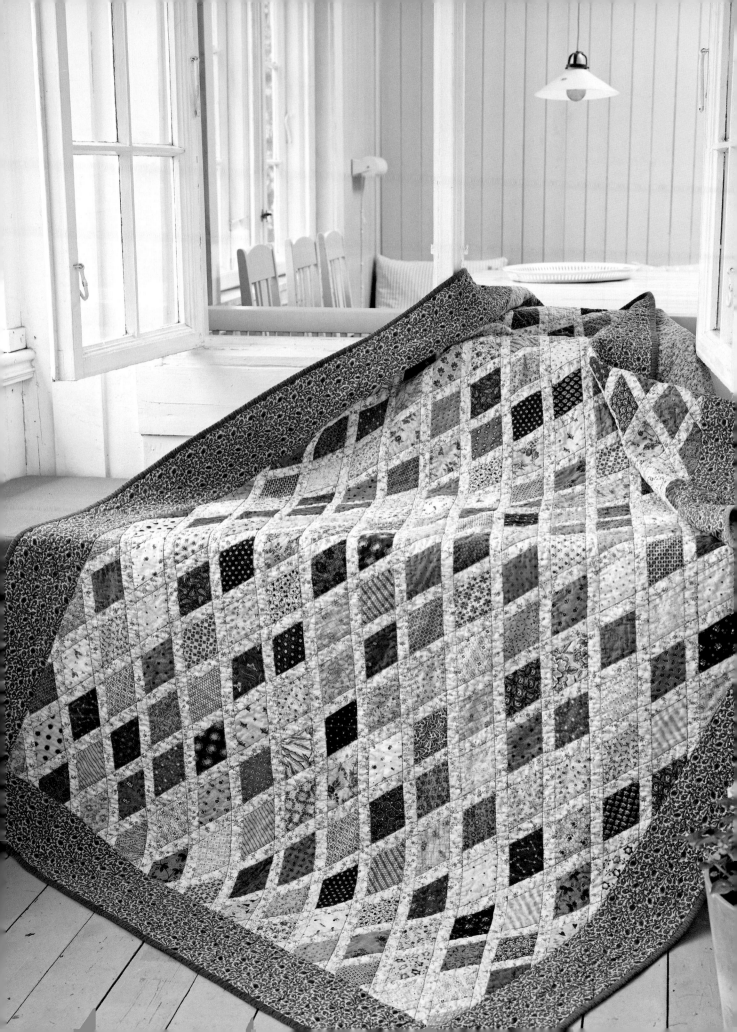

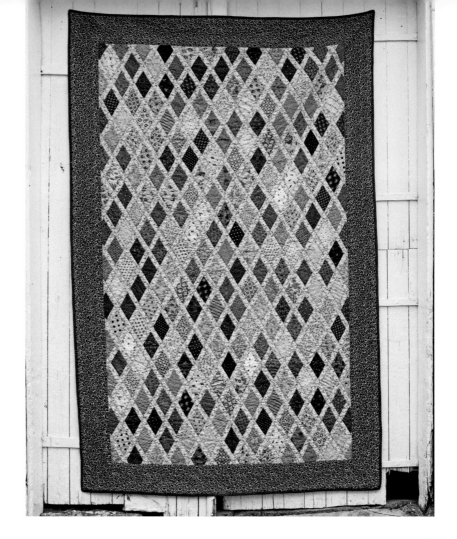

Tip

Would you like to sew by hand instead? Use Paper Pieces 3" 6-Point Diamond, and Paper Pieces 1" 6-Point Diamond. Divide a large ginger snap into three equal large parts with a knife and a ruler to make cardboard templates for the sashing. You use these together with the ginger snaps in a size of 1" to put together all of the sashing. Note that the relative distances and finished measures are not the same as the blanket you see illustrated if you use pre-punched cardboard for hand sewing. However, it is equally enough, not to mention that you can get the quilt sewn by hand.

1" (2 ½ cm)

3" (7 ½ cm)

and evaluate the results. The expression in the blanket changes character considerably depending on the sashing. More rigorous and pure composition is the result of bright fabric without strong pattern markings. A less contrasting blanket if you choose a fabric with subdued light colors and "batch" slightly darker "spots," for example, in the form of scattered rose buds. In the original blanket of Jane Austen's, the sashing fabric is bright with tiny, black dots in a dense pattern.

The fabric for the ginger snaps should have a contrast to the sashing. In addition, the ginger snap fabric can have two or more colors in the pattern. For example, it can be blue flowers on a red background or green dots on a purple background. I've used more colors and shades, from light to dark, through shades in the colors blue, brown, red, gold, beige, yellow, and gray.

Cutting Plan

Ginger snaps

Cut a strip of 3" (7 ½ cm).

Place the ruler on the strip with 60-degree marking along the strip's recently cut line. Trim the end of the strip. Then cut 3" ginger snaps. Together, you should have 265 diamonds. I have from one to three pieces of each fabric.

Sashing, long strips:

Cut long strips 1 ½" (3.8 cm) for the fabric's width. These will be used for all of the long stretches, diagonally in the blanket, a total of about 23 strips.

Between Works, small pieces

Cut strips of 3" (7 ½ cm). Place all of the fabrics with the right side up! This is IMPORTANT, otherwise, the half pieces of the latticework become mirror-like and impossible to use. Then cut 60 degrees as described for the ginger snaps and use a 1 ½" wide measure. You need 284 pieces.

Frames:

6" (15 cm) wide.

The Seam Work

Sew long strips of ginger snaps and small pieces of sashing. The length is determined by the picture. You use strips consisting of 1, 3, 5, etc., ginger snaps. Finally, the blanket is trimmed, therefore the blanket may be very "choppy" in the outer edges at this stage. Press—don't iron—the seam allowance toward the ginger snaps very carefully without stretching the strips.

Sew long sashing strips between ginger snaps as follows: Place right sides together, fold back, place the ginger snap at the right height in relation to the previous ginger snap row, hold firm, fold over to the right sides together again, and put a pin in. This must be done with each ginger snap. Do not stretch the strip. Or add the strip with the right side next to the last strip with sewn-on sashing and check the 60-degree angle and seam allowance on the long strip. Note the same on the ginger snap on the strip without long-sewn sashing. Securely pin the guide marks. Take an "angle control" every time a long strip is sewn like this: Place the blanket flat on the floor. Check that the blanket will be 90 degrees in the corners of the outer edge after it is trimmed. Also check that the ginger snaps across and lengthwise run parallel with the outer edges. My experience is that those who do not control every seam eventually end up with crooked blankets. This bias may be quite small or catastrophic. It is nicer to do one long seam than to take from the whole blanket! Trim the blanket's outer edge. Choose how the ginger snaps are placed on the line. Remember that

the seam allowance disappears when sewing on the edge. I have chosen to cut my ginger snaps so they're a few centimeters larger than the half. The idea is that you cut all the diamonds in between at the same point on each side. It is necessarily a different point on the top and bottom. At the same time, all four corners will be 90 degrees. Put on the frames that are 6" (15 cm) wide.

Quilting

The blanket is quilted by machine for all seams. The frame is inserted using a Borders Made Easy-roll of no. 102.

Border

As usual, it is cut 2 ¼" (6 cm) and sewn by machine from the right side and on by hand on the back side.

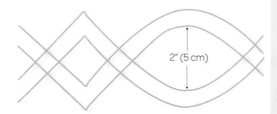

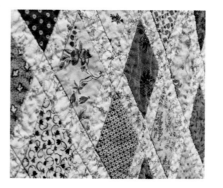

1.

Sewing together of sashing and ginger snaps

2.

Strip with ginger snap and sashing

3.

Make sure those lines inside the circles "aim" the same way/at the same angle

4.

The edge before trimming

Baby blankets should be wide enough so that they can be pushed firmly into the crib. On the other hand, they should be just about adequate in length. According to me, 28" (70 cm) is just right. The blanket can be folded lengthwise at the top of the golden child's head. Then it is of utmost importance that the blanket's back panel is beautiful and goes well with the front side. I tend to fold so the back panel is visible. It can be either one or two folds, depending on the length of the crib. The width is a full meter (40"). This way, you manage to tuck it down firmly in the crib lengthwise, then toward the bottom, and "lock" the whole package of duvets, wool blankets, and sheep skins. My kids have spent many winter days in cribs loaded to the brim with linens that are wrapped beautifully with a patchwork quilt. In summer, it can serve as a health blanket and patchwork quilt by itself.

In its past life, this quilt participated in a competition in my local quilt club. The invitation text was "Poultry." Placing? Finally, a jury with my taste!

Materials

For 28 blocks:
- A total of 36" (90 cm) of different light fabrics and 36" (90 cm) dark fabrics.

Filler fabric:
- 20" (50 cm) light-blue striped fabric.

Frames:
- 32" (80 cm) hen-patterned blue fabric.

Border:
- 12" (30 cm), 20" (50 cm) if you cut it at an angle for aesthetic reasons.

Backing and batting:
- 36" x 48" (90 cm x 120 cm).

Mother Hen Baby Blanket

A gender-neutral baby blanket in a size of about 28" x 40" (70 cm x 100 cm) pre-washed and shrunk
Size of pre-sewn block: 3"

The Anatomy

Twenty-eight quad-blocks are filled in with every other whole piece of cloth. I call this every-other of the blue-striped fabric "filler fabric." The fabric "fills out" and calms down most of the blocks—almost any color combination. The side triangles around the blanket are made a little too big. This way, it's easier to keep all of the points on the quad-blocks. The entire inside is "flowing," before the frame is put on. The frame has a hen motif, hence the baby blanket's title, "Mother Hen Baby Blanket."

Thoughts about Fabric Choice

If you know what the crib looks like, you have an advantage. Ask to borrow a part of the crib so you can customize the quilt colors to the crib color. You're not looking for perfect match, but would like to avoid cutting something terrible. For example, if a blue stroller is hard to match, then you might as well stay away from blue. Also consider the color and pattern on the crib before you get the fabric for the blanket. The idea is that the blanket can be used for both girls and boys. The baby-pink color is present, but harmless with purple, bright red, burgundy, and orange. Mint and olive are used with the blue to bring neutral colors and add a masculine veil throughout. You have a great opportunity to change the blanket's character when you find the filler fabric. The filler fabric is the whole pieces of blue-striped fabric between the quad-blocks. All quiet fabrics can be used here. Stripes, diamonds, and solid colors are good candidates. Pre-sew quad-blocks before you decide on the filler fabric—it's easier.

Cutting Plan

Blocks:

Each piece of the quad-block is cut 2" x 2" (5 cm x 5 cm).

You will sew 28 different combinations and, strictly speaking, need only 2 pieces 2" x 2" (5 cm x 5 cm) of each fabric. A total of 56 different fabrics. A simpler variation is to let all quad-blocks be exactly alike.

Filler Fabric

Cut the following three items from the light-blue striped fabric:

Whole filler fabric blocks:

18 squares 3 ½" x 3 ½" (about 9 cm x 9 cm).

Side Triangles:

5 squares 5 ¾" x 5 ¾" (15 cm x 15 cm) that are divided 2 times diagonally so you get 20 triangles. You use only 18 of them, so there will be two to spare.

Corner Triangles:

2 squares 3 ½" x 3 ½" (9 cm x 9 cm) divided once diagonally so you get 4 triangles.

Frames

Cut 2 long sides with a width of 5 ½" (14 cm).

The length is measured on your blanket.

Cut 2 short sides with a width of 5 ½" (14 cm).

You measure the length after the long sides are sewn on.

The Seam Work

Sew 28 quad-blocks. Sew the blanket's middle section so the sewing scheme shows. Iron the seam allowances toward the quad-blocks for the strips. When the strips are sewn together, you can split them or put them together one way.

Quilting

Stitching is sewn on all seams as well as across the pieces so they're divided the same way as the quad-blocks. The frame is quilted with Borders Made Easy no. 102, the same as used on "Ginger Snaps in Jane Austen's Direction," page 68.

Border

The border is cut 2 ¼" (5 ½ cm) at a bias to the fabric because plaid fabric like the border is prettier when it's cut on an angle. I think.

Tip

Sew the blocks before you cut the filler fabric. Pin your blocks and cut whole filler blocks for your measurement.

Be generous when you cut the side triangles and corner triangles. They can be trimmed after they're sewn on. This is especially clever if you sew in centimeters.

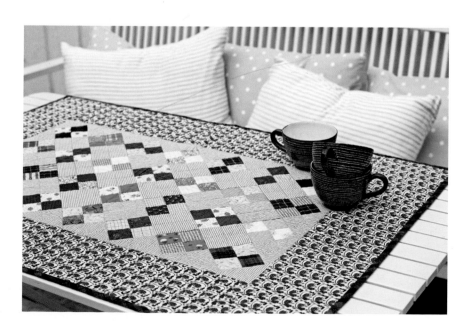

I am a basket person. There can never be too many of them. They're used for storing sewing things, of course. But in addition, baskets are used to collect like and unlike. For example, I put the kids' wet boots upside down inside a basket and put it back on the bathroom floor overnight to warm them from below. Then the baskets go out at a time when the kids can find dry boots. The baskets control clutter and help me carry things around the house. I have two baskets on the steps, one on the way up and one on the way down. So they're filled during the day and it's easy to take it all back and forth—you just hook the basket on your arm as you walk by. As you probably realize, my house is full of baskets. This quilt shows a small selection of them, and is a tribute to the basket as a transport device.

Materials

- For 5 basket blocks, diverse pieces in different colors, a total of 30" (75 cm). I used 40 different fabrics, 8 for each block.

Filler Fabric and the First Frame:
- 59" (1 ½ m).

Dice in the First Frame:
- 6" (15 cm) of 4 different fabrics.

Second Frame:
- 59" (1 ½ m).

Border:
- 12" (30 cm).

Backing and batting:
- about. 64" x 50" (160 cm x 125 cm).

- Application thread for the handles

All the Test Subjects in the Basket

Sofa blanket with baskets. The blanket measures about 56" x 41 ½" (140 x 104 cm) pre-washed and shrunk
Size of pre-sewn block 13" x 8 ⅛" (33 cm x 20 ½ cm)

The Anatomy

The blanket has five basket blocks and four filler fabric blocks of equal size. The first frame is in the filler fabric. In the corners there are four squares of different fabrics. The outer frame is light and easy. The border is dark for the framework's part.

Special Equipment

Tear-away paper or tracing paper for sewing on paper (basket's body and foot) and Vliesofix for application of the handles.

Thoughts about Fabric Choice

Wildness of rage is in this quilt. Purple, violet, green, mint, royal blue, red, orange, and yellow were chosen for the basket's details. Note that each basket has a little of almost all of the colors. It's

so not all colors in one basket are purple and another one green. The colors are spread out over all five blocks. The filler fabric is selected in a delicate khaki and pink to get a little quiet. The same meaning goes for the outer frame: It is equally light to gather it into a harmonious wholeness without too many colors.

Cutting Plan

Blocks:
Use the "Sew on paper technique." Draw lines on the tear-away paper, and sew by them with the machine. The fabrics are applied to the back panel based on the drawing.

Cut the base fabric that the handle will be appliquéd on, 5" x 9" (13 cm x 23 cm). The handles are appliquéd before you sew the piece on the rest of the block using the sew-on-paper technique. Cut the two horizontal strips 1 ½" x 9" (2 cm x 23 cm). Then let them enter into your future "paper seam" of the block. The rest of the fabric for the basket block is roughly cut freehand the way

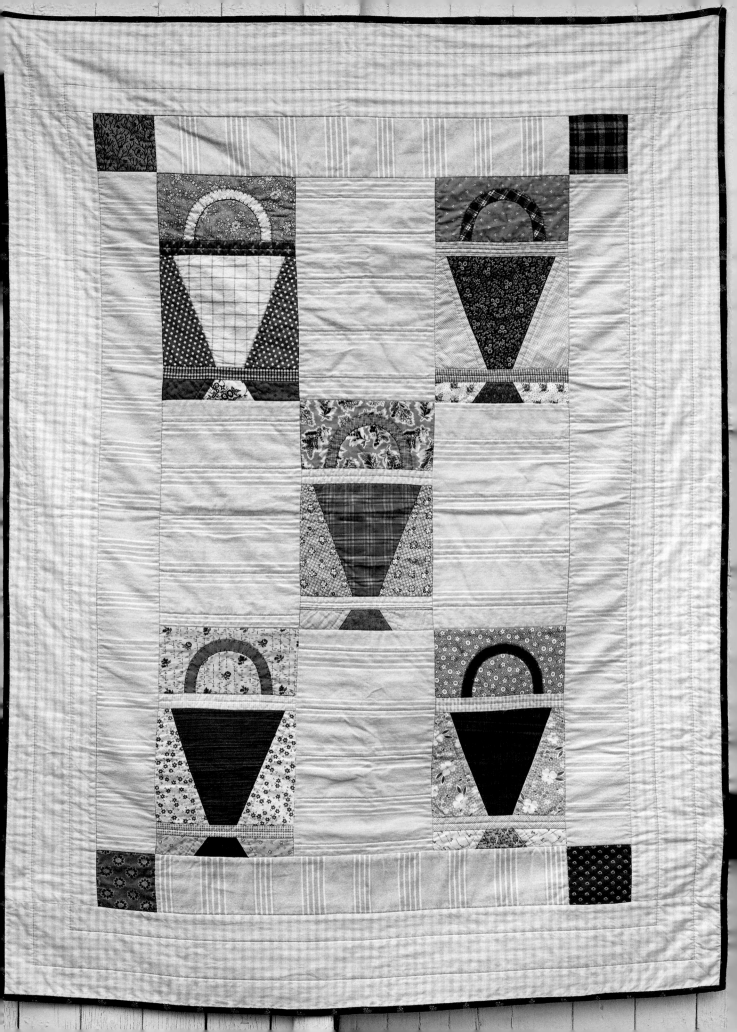

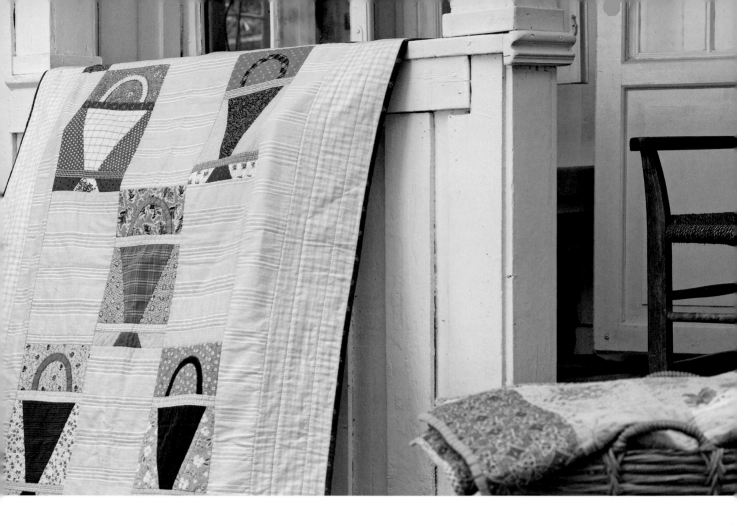

one does with a machine seam based on the mark.

Filler fabric and first frame:
Cut 4 pieces 8 5/8" x 13 ½" (measure your own basket blocks and cut the same measure) plus 2 pieces 4" x 24 7/8" and 2 pieces 4" x 39 ½" (cm x cm) (10 cm wide).

Dice in the first frame:
Cut 4 pieces 4" x 4" (10 cm x 10 cm).

Second frame:
Cut 2 pieces 6" x 42 7/8" and 2 pieces 6" x 46 ½" (15 cm wide).

The Seam Work

Sew five basket blocks:
Use the "sew on paper" technique. If you haven't mastered this technique, you can make hand seam measures of parts of the drawing and sew the pieces together with American hand sewing on the line.

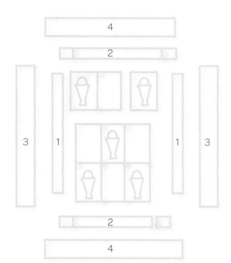

Or you could appliqué the basket and foot the same way as the handle. Then sew the three elements together in the horizontal seams.

Prepare the first base that the handle will be appliquéd to. Press it twice to have marks to help when you add the handle to the base fabric. Draw the handle on Vliesofix. Add a half-centimeter at the start, and stop, so that the handle can be caught in the seam between the base and top cross-strip when the time comes. Roughly cut out the Vliesofix, and iron it to the back side of the handle. Cut exactly. Pull off the protective paper. Use the marks and place the handle on the base. Let handle stick down where the seam will go afterward between the base and the first strip. Make sure the handle is centered. Iron it in place. Appliqué with heavy stitching on the machine or by hand. Break up the pattern so that you get three separate entities. They are sewn together in the end.

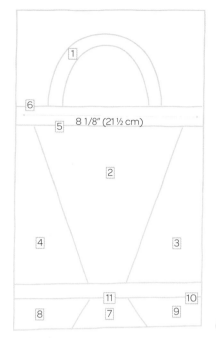

Order of "sew-on-paper"

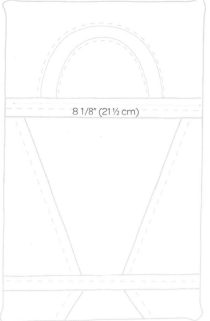

Quilting sketch

8 1/8" (21 ½ cm)

6" x 42⅞"
4" x 24⅞"
4x4
6" x 46½"
8⅝" x 13½"
4" x 39½"

Cutting Plan

The upper part is the handle and the top cross-stripe. The middle part is the basket itself. The bottom is the basket's foot or base. Each part is carried out with the "sew on paper" technique as follows:

Draw lines (including lines that eventually form the block's outer edge) on the tear-away paper or another transparent paper.

Add a fabric with the right side out on the back side of the paper. Pin the fabric in place. Place the next fabric on with the right side facing the first fabric. Pin. Check that the fabric will cover the entire piece and surrounding seam allowance. Sew on the line with tight stitching on the machine from the right side of the paper where you have drawn. Remove the pins and iron.

Cut the excess seam allowance. Re-pin parts that are loose. Add the next piece's right sides together, and proceed as described above by sewing from the paper side's marks and add the fabrics to the back side. It's the back side that, in the end, becomes the front. Trim the block ¼" outside the outer line. Did you hear? OUTSIDE.

Otherwise, you get no seam allowance to sew in. Sew the middle section so that there are basket blocks in five places and filler-fabric blocks in four. It goes on every other one. Sew the squares for the frame on the two short frames. Sew the two long frames on first, then the two short ones with square dice.

The outer frame is made as follows: the long one first, then the short one. See the sketch.

Quilting

Place the blanket on the batting and backing. Quilt in all of the blanket's seams. Also quilt along the handle, in the middle of the cross stripes, and a paw's length of the basket's vertical contours. See the sketch. The filler-fabric and the frames are simply quilted with longitudinal and transverse stitching.

Border

Cut the border 2 ¼" (5 ½ cm), cut along the entire circumference of the blanket, iron twice lengthwise with the right side out, and sew on with the machine from the court. Then sew it toward the reverse side by hand.

After a block offer on the Net, I obtained many stars. So far, I've made three blankets from offer operations, and this is the second. The first quilt is pictured in the book Lappesaker. You'll find the third under "Vertical Happiness," page 84. I've sewn 10 of the blocks in my blanket myself, and the last two are the contributions of sewing acquaintances online.

Yellow Streets

page 84

Sofa blanket with stars and yellow lattice work.
The blanket measures about 72" x 58" (118 cm x 145 cm) pre-washed and shrunk
Size of pre-sewn block sewn into the quilt: 9" (23 cm)

The Anatomy

The blocks are set up in a traditional manner. Each block has a mustard-yellow lattice around it. Sometimes, I call this latticework "streets." It stems from the blanket looking like a city map. For the hubs, I've added a pink dice. Two of the blocks have a dark background; the remaining 10 have a light ambience.

Thoughts about Fabric Choice

The yellow streets are a is a major determining factor of how the blanket will look. Likewise with the noticeable pink dice in the middle of the streets. The blocks are quite normal in blue, white, and red fabrics.

Cutting Plan Blocks
Autograph Star
The middle strip is intended for a small signature from, for example, the giver.
A: 4 light squares 2 ¾" x 2 ¾" (about 7 ½" cm x 7 ½" cm).

B: 1 bright square 5 ¾" x 5 ¾" (about 14 ½" cm x 14 ½" cm) divided diagonally twice into 4 triangles.
C: 4 dark squares 3 1/8" x 3 1/8" (about 8 cm x 8 cm) divided diagonally once into 8 triangles.
D: 2 dark and 1 bright rectangles 5" x 2" (about 12 ½ cm x 5 cm).

Saw tooth star:
A: 4 light squares 2 ¾"" x 2 ¾" (about 7 ½" cm x 7 ½" cm).
B: 1 bright square 5 ¾" x 5 ¾" (about 14 ½" cm x 14 ½" cm) divided diagonally twice into 4 triangles.
C: 4 dark squares 3 1/8" x 3 1/8" (about 8 cm x 8 cm) divided diagonally once into 8 triangles.
D: 1 dark-, light-, or medium-toned square 5" x 5" (about 12 ½ cm x 12 ½ cm).

Materials

For 12 blocks:
- 8" (20 cm) yellow.
- 12" (30 cm) red.
- 12" (30 cm) slightly lighter red.
- 28" (70 cm) blue.
- 36" (90 cm) slightly lighter blue.
- 20" (50 cm) bright base.
For the rest of the blanket
Streets:
- about 40" (1 m) mustard-colored fabric.
Dice:
- 12" (30 cm) pink fabric.
Frame:
- About 51" (1.3 m) dark blue fabric.
Border:
- 24" (60 cm) peach-colored fabric.
Backing and batting 52" x 60" (130 cm x 150 cm).

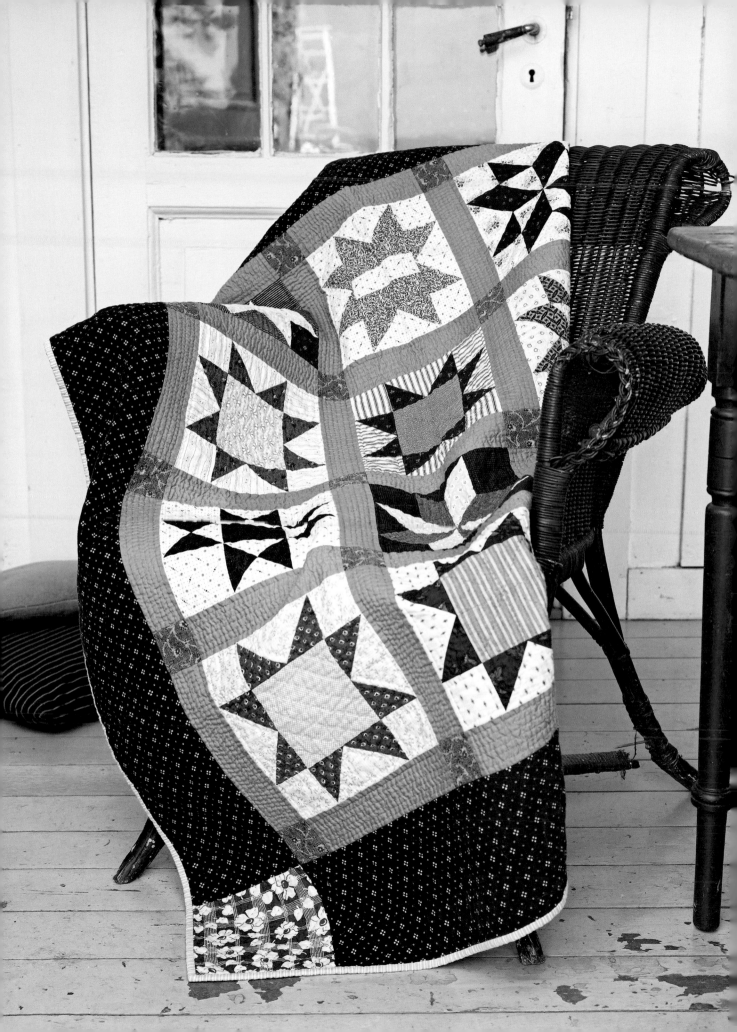

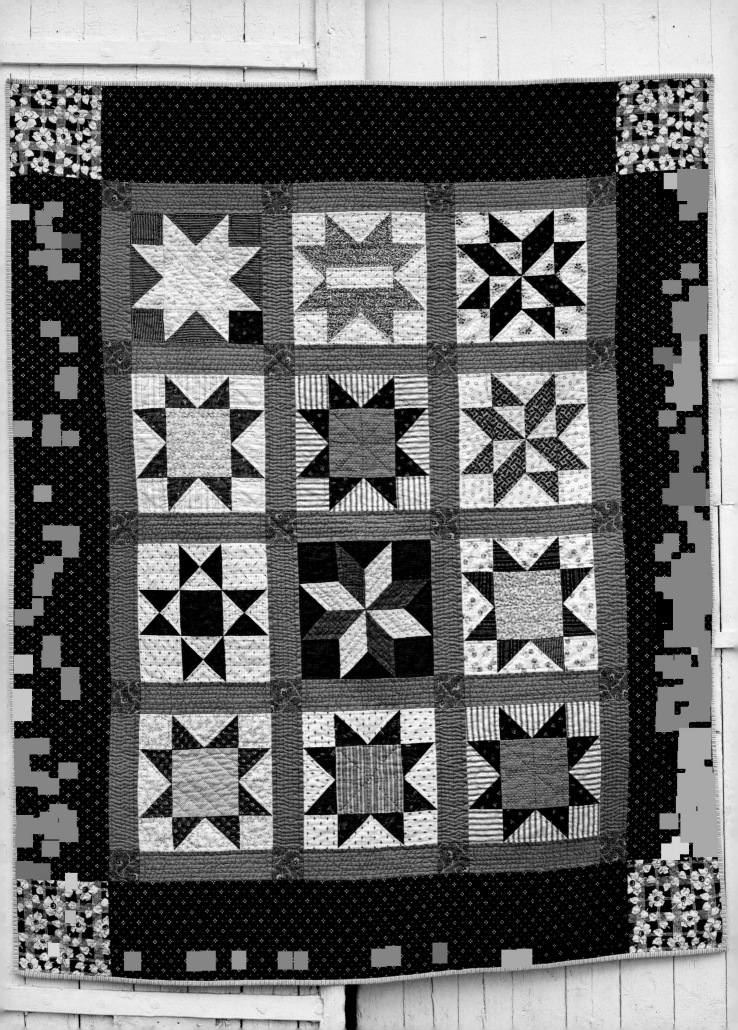

*Saw tooth star with
cartwheel feed:*

Replace the star middle with a cartwheel made of 4 oblique squares as follows:

A: 4 light squares 2 ¾" x 2 ¾" (about 7 ½" cm x 7 ½" cm).

B: 1 bright square 5 ¾" x 5 ¾" (about 14 ½" cm x 14 ½" cm) divided diagonally twice into 4 triangles.

C: 6 dark squares 3 1/8" x 3 1/8" (about 8 cm x 8 cm) divided diagonally once into 12 triangles.

C: 2 light squares 3 1/8" x 3 1/8" (about 8 cm x 8 cm) divided diagonally once into 4 triangles.

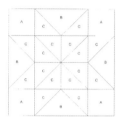

Anne-Kjersti's star:

A: 4 bright and 1 dark squares 3 ½" x 3 ½" (about 9 cm x 9 cm).

B: 2 light and 2 dark squares on 4 ¼" x 4 ¼" (11 ½" cm x 11 ½" cm) divided diagonally twice into 8 light and 8 dark triangles.

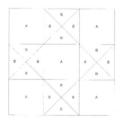

Eight-Petal Rose

I recommend making cardboard templates and sewing this by hand as described under "Eight-Petal Rose in Original Transfer," page 94. Finished size for the blocks for "Yellow Streets" is 9," eight-petal rose in "Original Transfer" is larger. Do not mix them.

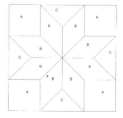

Cutting Plan—Sashing and Borders

Yellow streets:

One street is cut 9 ½" x 2 ½" (24 cm x 6.35 cm). You need a total of 31 pieces.

Cornerstones:

24 pieces of pink fabric 2 ½" x 2 ½" (6.35 cm x 6.35 cm).

Frames:

Two blue-colored ones 7" x 46 ½" (18 cm x 116 ½" cm) and 2 in the same fabric 7" x 35 ½" (18 cm x 89 cm). Corner dice are cut 7" x 7" (18 cm x 18 cm) and there are 4 of them.

The Seam Work

Sew all of the star bases on the sketch. Take turns so that you sometimes have a dark base, a bright star middle, and preferably a remnant corner in between. Sew the blanket together with stars in strips with streets in between. Sew a row of streets together with the dice and sew it in between the stars again. Sew on the frame by attaching the corner dice to the short frames. Sew the long frames first, then the short ones. See sewing scheme for "Rose Bud in All Secrecy" on page 33.

Quilting

This quilt is one of Anne Fjellvær's foster children; it's basically hand quilted by her. She is a merciful angel who scatters help and inspiration about her. Anne has used Lene's silk thread and a little rough stitching on the hand quilting. Inside the border, a shell pattern is made; the streets that make up the border have grooved stripes; the cornerstones, a cross pattern; and all of the blocks have simple lines and seam-allowance markings. See sketch for reference.

Border

A light peach strip cut 2 ¼" (5 ½ cm).

Quilting sketch

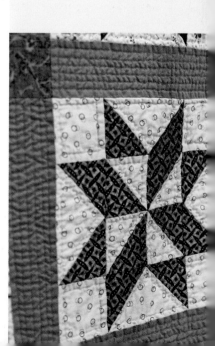

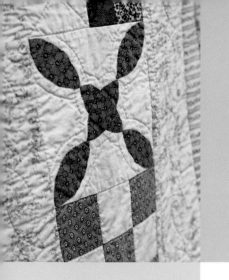

Many of the blocks in the quilt come from a block exchange online. It was arranged by Helene Juul, if my memory is right. Contributors include (using the same rikety memory): Pia Lihme Petersen and Birgit Dam Jensen from Denmark, Jenny Yale from Australia, Tania Jones from Canada, Caroline and Kimberly Pratt from the USA, and myself.

Vertical Luck

Materials

For 18 blocks:
- A total of 59" (1 ½ m) bright, solid-colored fabrics
- 18 different fabrics for each of blocks. Virtually each block has one neutral light, and one patterned fabric. It is sufficient with 4" x 12" (10 x 30 cm) of each fabric.

Filler Fabric:
- 20" (50 cm) light turquoise fabric for sashing
- 6" (15 cm) pink fabric for the firming border on the left and right side
- 20" (50 cm) blue-checkered fabric for edge on top and bottom

Border:
- 3 ¾ (1 ½ m) large-patterned gray fabric

Binding:
- 20" (50 cm) dark apricot plaid fabric, cut 2 ½" (6 ¼ cm) wide

Backing and Batting:
- about 56"x 66" (140 cm x 165 cm)

The blanket measures about 45 ¼" x 56" (113 x 140 cm) pre-washed and shrunk

Size of pre-sewn block: 6" (15 cm)

The Anatomy

The arrangement is vertical, as the title says. Six blocks are placed close together on top of each other in a long row. This is done for three rows, a total of 18 blocks. The rows are defined from each other with latticework in light turquoise. Outside, there is a pink firming up each side. The top and bottom have a blue edge. The frame is largely patterned in gray and purple.

Thoughts about Fabric Choice

The blanket carries off a good collection of reproduction fabrics. There are re-printed old-fashioned fabrics dating back one or even two hundred years. The bright and solid-colored ones are almost all collected from different origins, but they still bind the blanket together because they all contribute to creating peace. Both the latticework and the first two frames in the filler-fabric are all closely matched. There is a gradual transition in color and rank.

Cutting plan blocks

Double Squares:
Small squares cut 2" x 2" (5 cm x 5 cm). Large ones are cut 3 ½" x 3 ½" (about 9 cm x 9 cm).

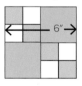

Musical Chairs:
Corner squares are cut 2" x 2" (5 cm x 5 cm).
The rectangles: 2" x 3" (5 cm x 7 ½ cm).
The middle: 3 ½" x 3 ½" (about 9 cm x 9 cm).

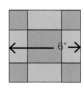

Cart wheel with suction cups:
Squares of 2 3/8" x 2 3/8" (about 5 ½ cm x 5 ½ cm) are divided diagonally once to make triangles. Alternatively, you can use an angled squaretriangle paper finished to a size of 1 ½" (3 ½ cm). Rectangles are cut 2" x 3 ½" (about 5 cm x 9 cm).

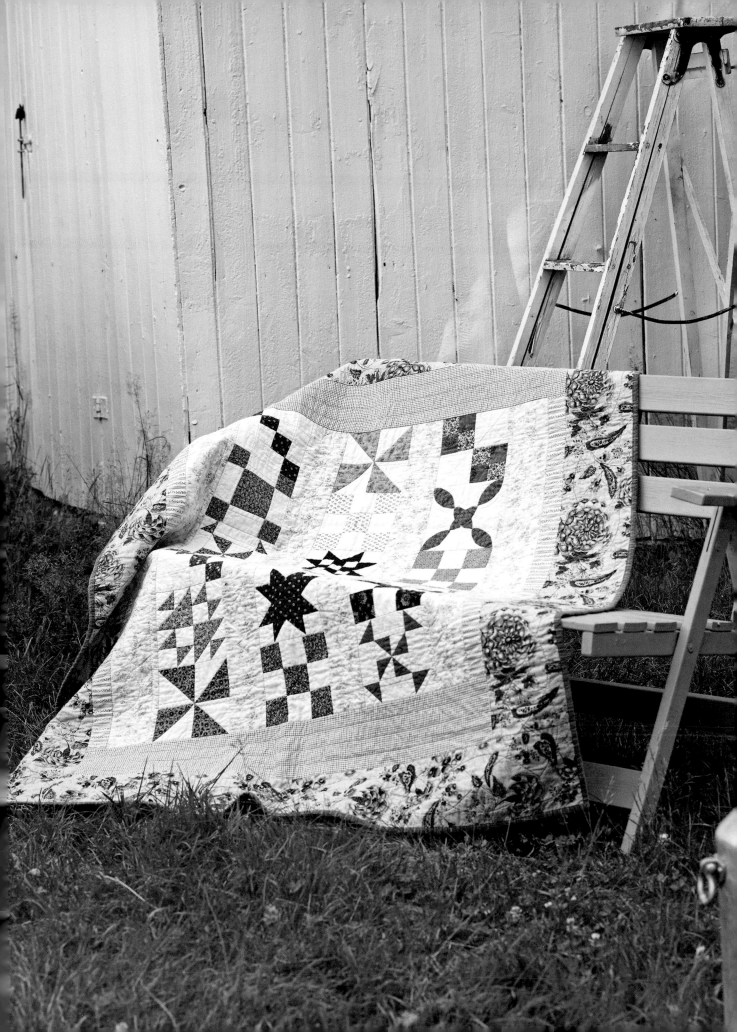

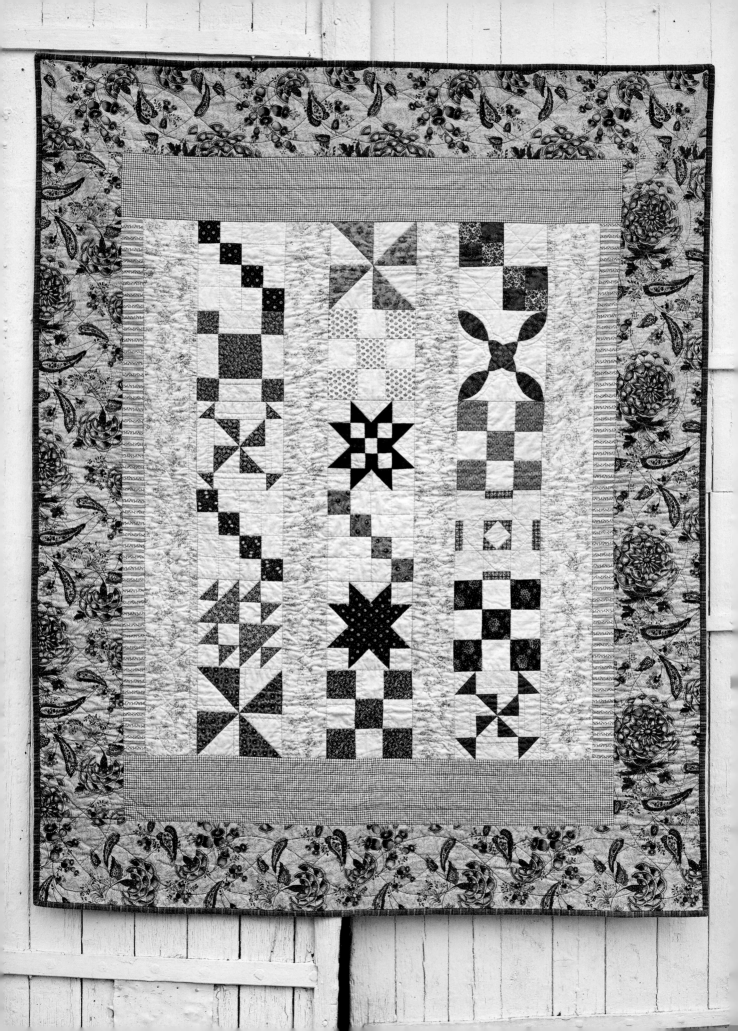

Old maid puzzle mills:
Squares of 2 3/8" x 2 3/8" (about 5 ½ cm x 5 ½ cm) divided diagonally once to get the small triangles.
The squares are cut 2" x 2" (5 cm x 5 cm). The large triangles are cut by dividing a square of 3 7/8" x 3 7/8" (about 10 cm x 10cm) diagonally once.

Cartwheel:
The large triangles are cut by dividing a square of 3 7/8" x 3 7/8" (about 10 cm x 10cm) diagonally once. Alternatively you can use the triangle paper finished to a size of 3".

Nine Block:
Each square is cut 2 ½" x 2 ½" (about 6 cm x 6 cm).

Sawtooth Star:
The corner is cut 2" x 2" (5 cm x 5 cm).
The center is cut 3 ½" x 3 ½" (about 9 cm x 9 cm).
Squares of 2 3/8" x 2 3/8" (about 5 ½ cm x 5 ½ cm) are divided diagonally once to get the dark, small triangles. The bright and large triangles are created by dividing a square of 4 ¼" x 4 ¼" (about 11 ½ cm x 11 ½ cm) diagonally twice.

Sawtooth Star with Nine Block:
The Nine Block's squares are cut 1 ½" x 1 ½" (about 3 ½ cm x 3 ½ cm). The rest of the measurements can be found under Sawtooth Star.

Propeller Blades:
The base is cut 6 ½" x 6 ½" (about 16 ½ cm x 16 ½ cm).
The leaves are appliquéd.

Sour Cream Porridge with a Dot of Butter:
The corners are cut 2 ½" x 2 ½" (about 6 cm x 6 cm). The small, yellow rectangles are cut 2 ½" x 1" (about 6 cm x 2 ½ cm). The large, white rectangles cut 2 ½" x 2" (about 6 cm x 5 cm). The light one is in the middle 1 7/8" x 1 7/8" (4 ½ cm x 4 ½ cm). Triangles are cut as follows: A square of 1 7/8" x 1 7/8" (4 ½ cm x 4 ½ cm) divided diagonally once.

Filler Fabric
Latticework in light turquoise: Cut 4 pieces. 4" x 36 ½" (10 cm x 92 cm).
Firming frame in pink: Cut 2 pieces 2" x 36 ½" (5 cm x 92 cm). Blue edge on top and bottom: Cut 2 pieces 5" x 35 ½" (12 ½ cm x 59 cm).

Frames
Vertical: Cut 6" x 45 ½" (15 cm x 113 ¼ cm).
Horizontal: Cut 6 ½" x 46 ½" (16 ½ cm x 116 ¼ cm).

The Seam Work
Sew all the blocks using the cutting guide here or by using line drawings in the back of the book. Some of the blocks appear several times. When the block is repeated, it is sewn with new fabric combinations. You have to sew four blocks of the "Double Square" and "Nine." The "Cartwheel with Suction Cups," and "Cartwheel" are sewn in two color variants each.

Quilting
The blanket is quilted in all seams—moreover, several blocks marked by stitching parallel to the seams and with crosses over open places. In particular, the light, solid-color fields have more depth with a little extra quilting. The turquoise latticework is quilted with Borders Made Easy no. 105 (see "Kitchen Tablecloth," page 64). The blue-checkered, horizontal edges have three longitudinal stitchings. The outer edge is machine quilted with Borders Made Easy no. 113.

1:1

1½"

The pillow is assembled relatively complexly with inserts and ties at the top. Feel free to skip over these difficult things by assembling the pillow more ordinarily with, for example, a whole back panel made of a shirt front with a finished button placket. I would say there's much ado about my way of assembling that may not be worth the effort.

Crow Seeks Mate

Materials

- (55 cm) application background, gray-brown, plaid 19 ½" (width) x 20 ½" (heigth) (50 cm x 52 cm).
- 4" (10 cm) of 19 different remnants for the urn, birds, wings, stem, flowers, and leaves.
- Vliesofix.
- Application thread for machine.
- 2 cushion inserts, blue-patterned, 19 ½" x 8" (50 cm x 20 cm).
- 1 pillow back, light brown with red dots at 19 ½" (width) x 20 ½" (heigth) (50 cm x 52 cm).
- 2 straps, red-striped at 13" x 3 ½" (33 cm x 9 cm).
- 2 straps red-striped 10" x 3 ½" (25 cm x 9 cm).
- Cotton batting in a size of about 24" x 60" (60 cm x 150 cm).
- Inner cushion about 19 ½" x 19 ½" (50 cm x 50 cm) or 19 ½" x 24" (50 cm x 60 cm).

Pillow size about 19 ¼" x 20 ½" (48 cm x 51 cm)

The Seam and Batting of the Pillow Front

Draw all of the application's components separately on Vliesofix's paper side. Cut them out roughly.

Iron onto the back sides of the bird fabric, the wing fabric, etc. Cut by the line. Remove the paper.

Iron all parts on the application's plaid background. Tack the batting to the application background's reverse side. Appliqué with heavy stitching on the machine through both the batting and the application background. This is

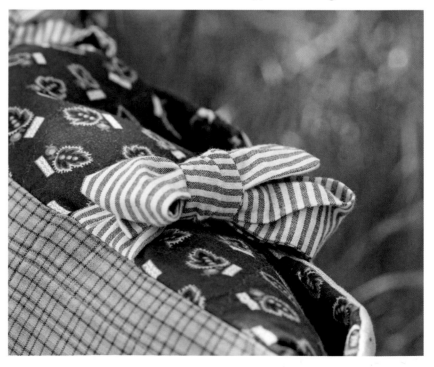

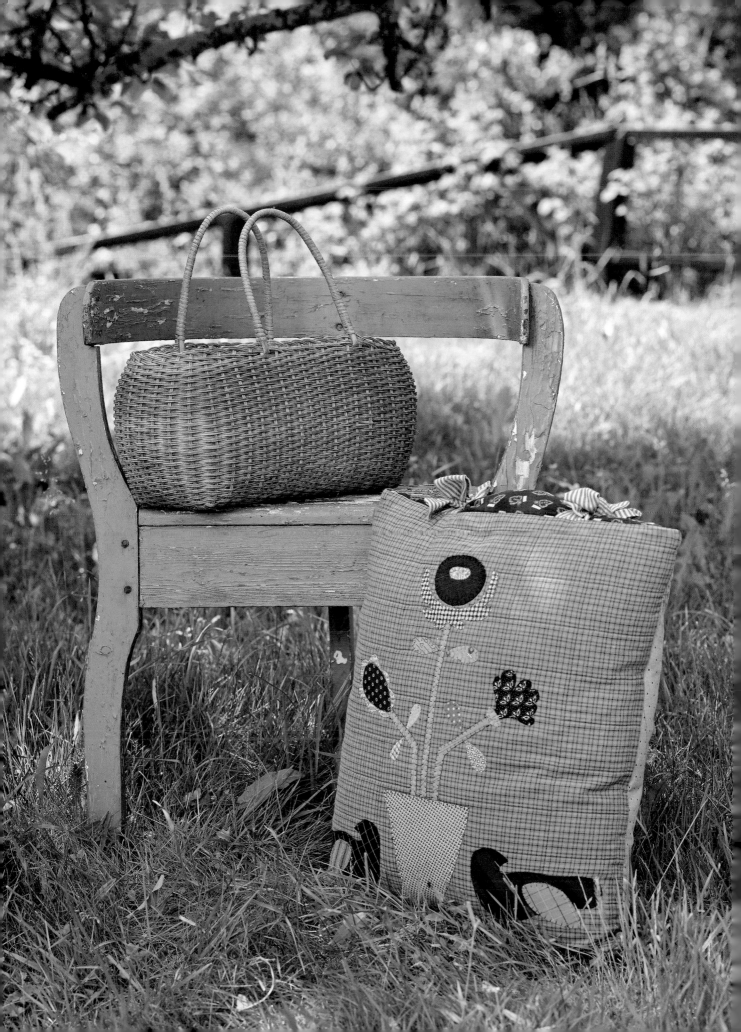

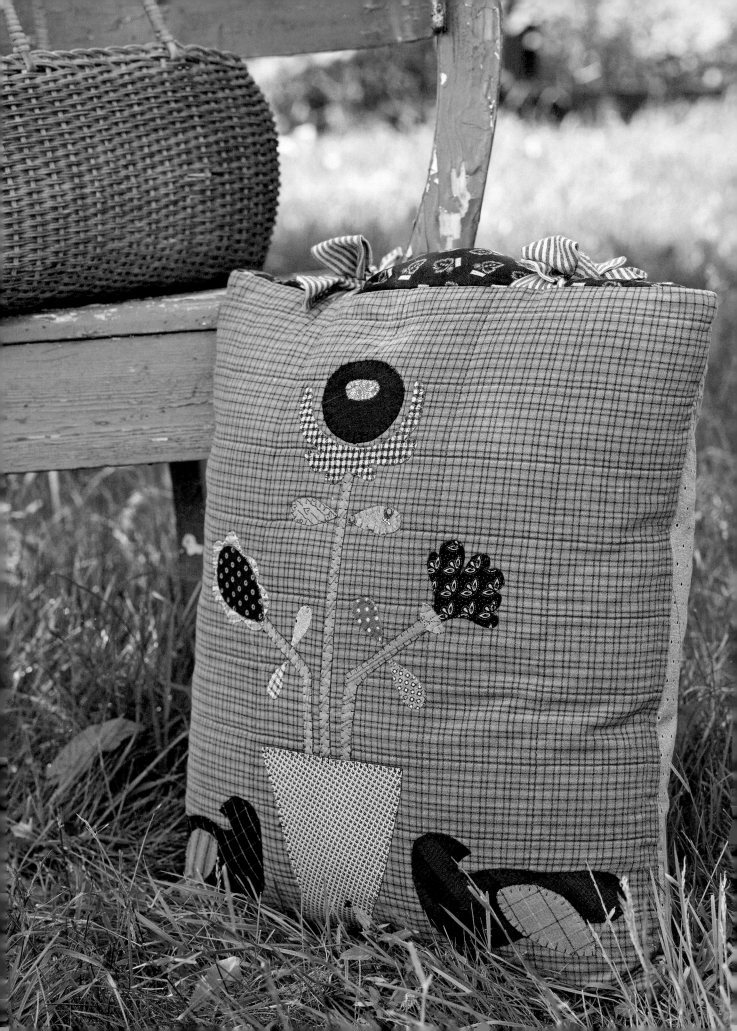

how the stitching becomes quilting at the same time. If you want to appliqué by hand, this should be done before the batting is tacked on. Then attach the batting to the back panel and quilt around the whole subject. Quilt a simple checkerboard pattern on the plaid fabric. Do not quilt over the subject. Sew a close zigzag around the whole pillow front. Trim up to the zigzag.

Sewing the Rest of the Pillow

2 cushion inserts at 19 ½" x 8" (50 cm x 20 cm).
1 pillow back side 19 ½" (width) x 20 ½" (height) (50 cm x 52 cm).
Batting pieces for all over.
Tack the fabric to the batting or use spray glue and quilt through both layers, for example, diagonally up to the edge. Sew zigzag around each piece.
Cut 2 straps 13" x 3 ½" (33 cm x 9 cm)
Cut 2 straps 10" x 3 ½" (25 cm x 9 cm).

Fold the straps twice along the reverse side. Sew along the top and one side. Turn right side out and press. See the sketch. Hem into the long side of each of the inserts.

Add an insert and the pillow front right sides together at the top of the pillow front with two equally long straps in between. The straps lie with the raw edges sticking out a little off the top of the pillow and the rest inside the two layers. The insert's hem lies down over. See the sketch. Sew along the top. Press.

Do the same with the back of the pillow, the last insert, and the last two straps.

Add front and back piece right sides together with the back piece's insert down over. Fold the front's insert up over and then down over the outside of the back piece. See the sketch. Add at the bottom of the front (with the right side up and the insert's right side up) on the table in front of you. Then add back on top (with the wrong side up, and the insert's right side down, outermost). Grasp the front's insert, and put it on top of the pile with the wrong side out and down.

Pin well and sew along three sides of the pillow, not across the top. Fasten. Turn and add an inner pillow in place behind the front's insert. Tie loops at the top of the pillow with the straps.

Strap, reverse side

5 ¼" (13 cm)

Pillow front insert, reverse side

Pillow front, right side out

Pillow front insert, right side out

Pillow front, right side out

... first:
At the bottom 1

Pillow front insert, right side out

The back side insert, right side out

The back side of the pillow, reverse side ... then
In the middle 2

Pillow front insert, reverse side

The back side, reverse side

... Finally, the top 3

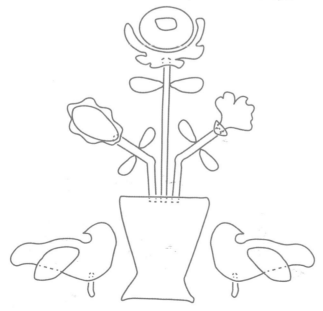

Chef's Apron from a Kitchen Towel

Materials

- 1 kitchen towel.
- 90 ½" (2.3 m) band (suitable for a narrow waist).

HERE'S HOW:

Fold the band at each end. Sew the band to the towel's short side 2" (5 cm) from the top. Let the one band end be longer than the other so that the apron can be tied on the hip side. The band then is crossed in the back and brought around to be tied at the side in front. Fasten the band with 2 sewing machine seams along the towel. Draw a monogram center front on the apron with chalk, and embroider with tack stitching by hand.

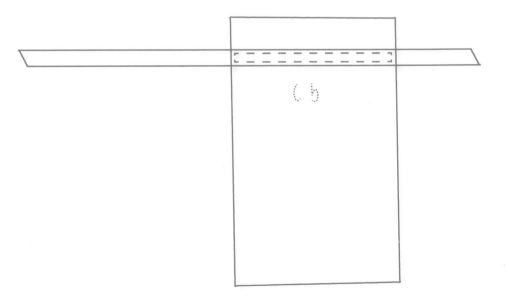

This is the first eight-leaf rose blanket in my sewing circle that was sewn over pre-punched cardboard by hand. I had been fascinated by the blocks for a long time, but avoided sewing because it called for inset seams by machine—or, alternatively, that I made my own hand seam measures in cardboard. It was too much of a fuss and therefore stopped me. After some detective work—and some ongoing questions—it turned out that it was actually possible to get a hold of the cardboard that was pre-cut. Then, I said, it got going.

Materials

For 24 blocks:

Bottom:
- 6" (15 cm) of 24 different fabrics for bases of 24 blocks.
- 6" (15 cm) of 24 different fabrics for half of the eight-petal rose (4 petals) on 24 blocks.
- 6" (15 cm) of 24 other different fabrics for the other half of the eight-petal rose (4 petals) on 24 blocks.
- If you stick to the same fabrics for each and every eight-petal rose, the material needs 34" (85 cm) of each of the two fabrics for the rose and 59" (1 ½ m) for the bases in the blocks.

Filler fabric:
- 106.3" (2.7 m) medium gray-brown plaid.

Frame:
- 90 ½" (2.3m) red fabric,

Border:
- 24" (60 cm) white and black striped fabric.

Backing and batting:
- 88" x 16" (220 cm x 290 cm).

Eight-Petal Rose in Original Transfer

The blanket measures (200 cm x 267 cm) pre-washed and shrunk.
The size of a pre-sewn block is 10 ¼".

Hand stitching has been going on for a long time, and it has infected many in its path. This quilt has inspired patchwork ladies throughout Norway to go ahead with hand-sewn quilts in the eight-petal rose pattern. Now the hope is that you will start up as well. Thanks to Anne Kjersti who showed me the first block and who hand quilted the entire blanket for me, she is a master of this technique. And, not least, thanks to Asa Wettre, who, in his book, *Gamla svenska lapptäcken,* on page 106, discloses the blankets of Maria Erikson (1863-1951).

The Anatomy
Twenty-four blocks are made that are set on the tip in a format of 6 x 4 blocks. The filler-fabric is also set on the tip, every other one with the blocks. The frame is fairly broad in order to balance large blanket and the patterned fabric frame.

Thoughts about Fabric Choice
Eight-petal roses are sewn mainly in red, blue, brown, black, and gray fabrics. An occasional light-yellow piece has snuck itself in. All block bases are relatively light. Some of them approach the filler fabric in rank. Nine of 24 blocks are negative, so that the base seems darker than the rose. The other is "normal," so that the base appears to be lighter than the petals of the rose. The filler fabric is lightly checkered and a quite dull gray brown. The frame, however, is cheerful. Be sure to vary the color and fabric patterns in each eight-petal rose.

Special Equipment
Pre-punched cardboard templates from Paper Pieces. A packet each of the 3" square, 3" half square triangle and 3" 8-point diamond—perhaps thin cardboard so you can create your own templates by the pattern in the book.

Silk thread for hand sewing and good needles (for example, Piecemaker's Appliqué needles).

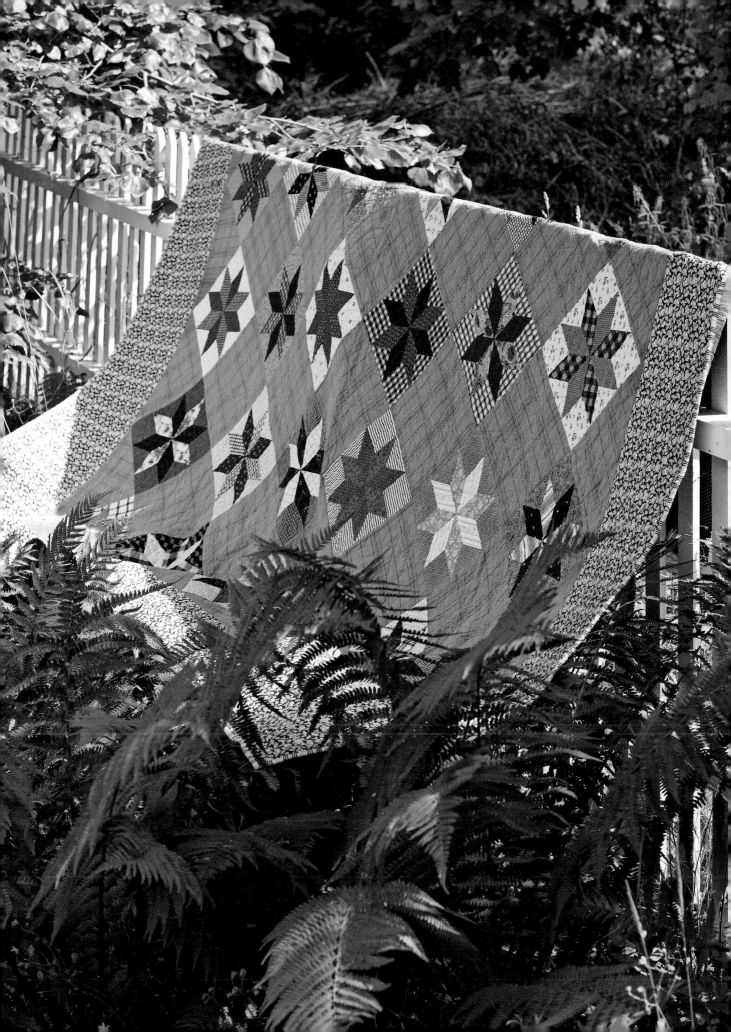

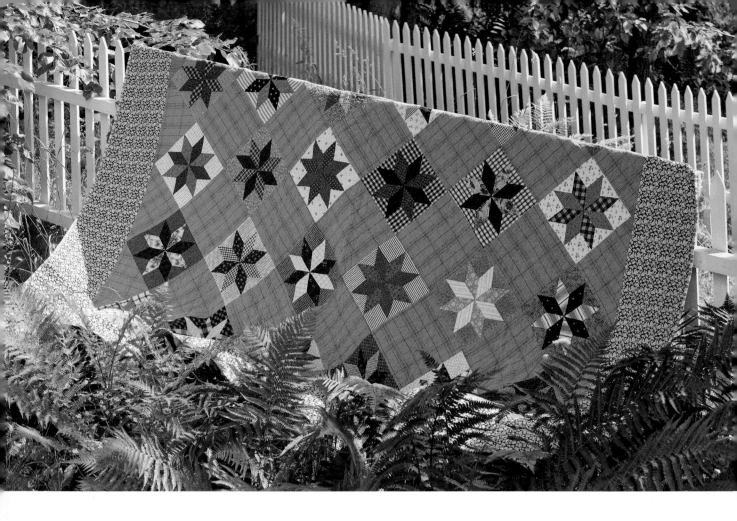

The Seam Work

The blocks are sewn together by hand over the cardboard. The outline of the block is drawn on BEFORE the cardboard is removed after the sewing. Then the rest of the top is sewn on the machine. The quilting is performed by hand in a corn-yellow color from Lene's silk in a fan pattern that spreads like an echo across the surface.

Eight-Petal Roses

Attach the cardboard template to the fabric with a pair of pins. Cut the fabric so you get seam allowance around each piece of cardboard. Put some effort in getting the seam allowance even around the whole thing.

Cut away the tip of the fabric in the star tip.

Tack through the cardboard and fabric to keep the material fixed in place. Start with a knot and finish with a couple of stitches, so you can later remove the tacking stitches a little easier.

Note that the tips each turn their own way on rose petal. Tack all of the rose petals in the same way.

Put two and two rose petals toward each other right sides together, and sew them together with throwing stitches only in the fabric folds. Just catch the fabric, don't trap the cardboard. Sew a half-rose. Add a half.

The tips will lie in a rosette in a row in the middle. This happens because you have been careful to get the tips to turn the same way on the rose petals when you

tacked. Later, the sewing together and quilting gets simpler when you have got to this.

Align the two halves exactly, and sew them together. Use a lot of effort to try to get the center as even as possible. Preferably put in the pins to hold the pieces in place.

Tack the fabric to the cardboard forming the rose background. Here, we let the edges remain untouched because later we want to use the machine to sew the blocks. If you want to use hand sewing, you have to tack all four sides over the cardboard just like with the rose petals.

For machine sewing: Draw seam lines along the cardboard that are not tacked. When one eight-petal rose block is hand-sewn, you can take out the cardboard—mind you, after you are sure that you have drawn up a seam line in the block's outer edge. You make it with a pencil and light hand on the reverse side of the block. The mark will go just at the edge of the cardboard piece around the whole thing. Trim the block using this line so that you get an even seam allowance outside the mark. I used a little more than a quarter inch—about 3/8" (about 1 cm).

Filler Fabric Cutting Plan

Every-other-one blocks:
15 pieces 10 ¾" x 10 ¾" (I used 11" x 11" in reality, so I had a little to go with, 27-28 cm).

Side Triangles:
4 piece squares at 15 ¾" (40 cm) divided diagonally 2 times so you get 16 side triangles (I used 16" x 16" in reality to have a little wiggle room).

Corner Triangles:
2 piece squares 8 1/8" (21 cm) divided diagonally once so that you get 4 side triangles.

Sew the blanket together diagonally, based on the sketch on page 94.

Frames

Of all things, the frame is cut 10 ¾" (27-28 cm)—the same dimensions as the block. It is purely a coincidence and something I try to avoid. In fact, my frames are not cut based on a measure. They're cut to a width that visually beautifies the fabric at the edge and the center of the blanket at the same time. With just this material and this framework, it turns out that the figure was 10 ¾". You're welcome to use the same, but I would most recommend you use your eyes.

Quilting

The blanket is assembled with beautiful and thin cotton batting from Soft Touch. The hand quilting is, as mentioned, carried out by Anne Fjellvær, my sparring partner in the fabric game. She has used the stencil "Bishops Fan 8." I translate "Bishops Fan" to "China Fan." The pattern can be found at the bottom of the page. It can be transmitted using tulle and a light pencil line.

Border

About 393.7" (10 m) border cut at 2 ¼" is adequate.

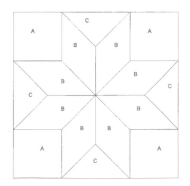

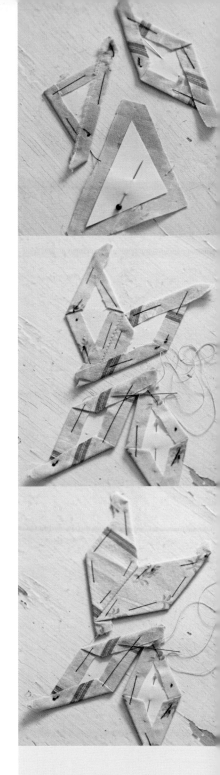

Quilting sketch

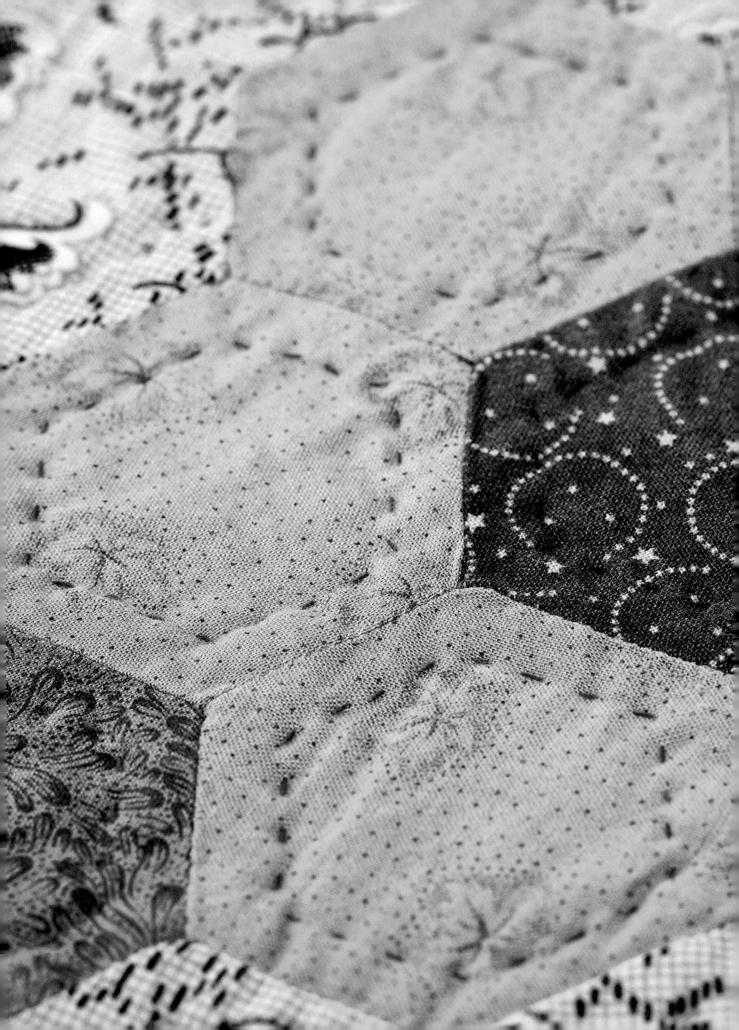

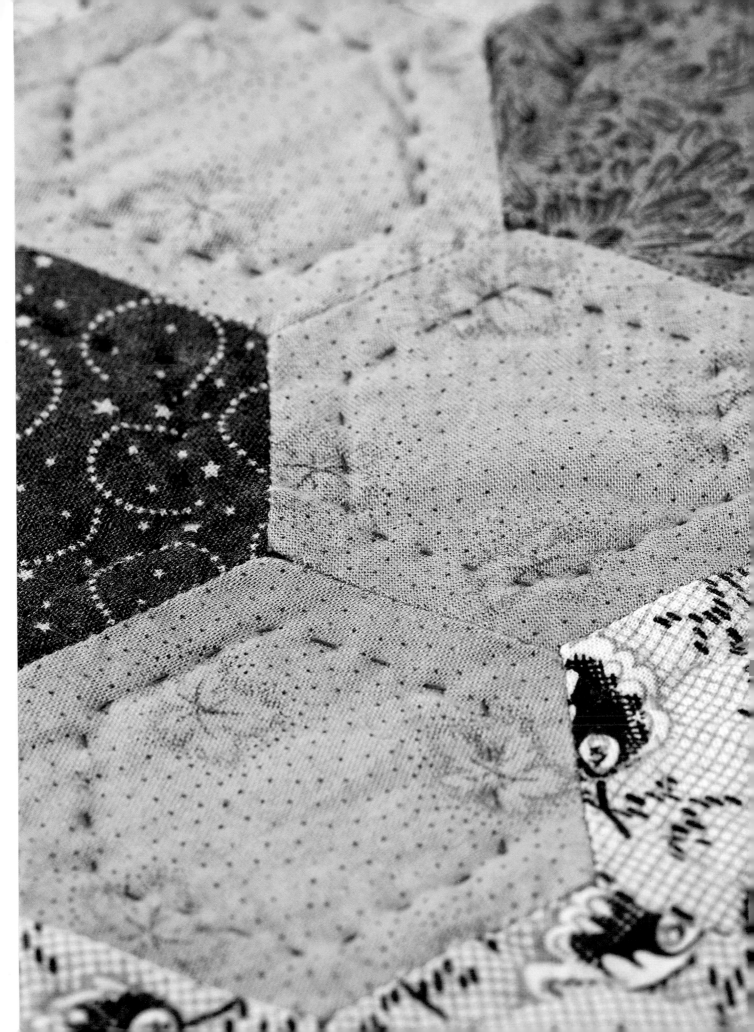

Patchwork Quilts

Notes

Patchwork Quilts

Notes

Patchwork Quilts